Coloring Books for Grownups
KANJI WORDS

VISIT TODAY
ILoveColoringBooksForAdults.com
TO WIN A SET OF PREMIUM COLORED PENCILS

All rights reserved. No part of this book may be reproduced or transmitted in any form by any means, electronic or mechanical, including photocopying, scanning and recording, or by any information storage and retrieval system, without permission in writing from the publisher, except for the review for inclusion in a magazine, newpaper or broadcast.

Cover and page design by Cool Journals Studios - Copyright 2016

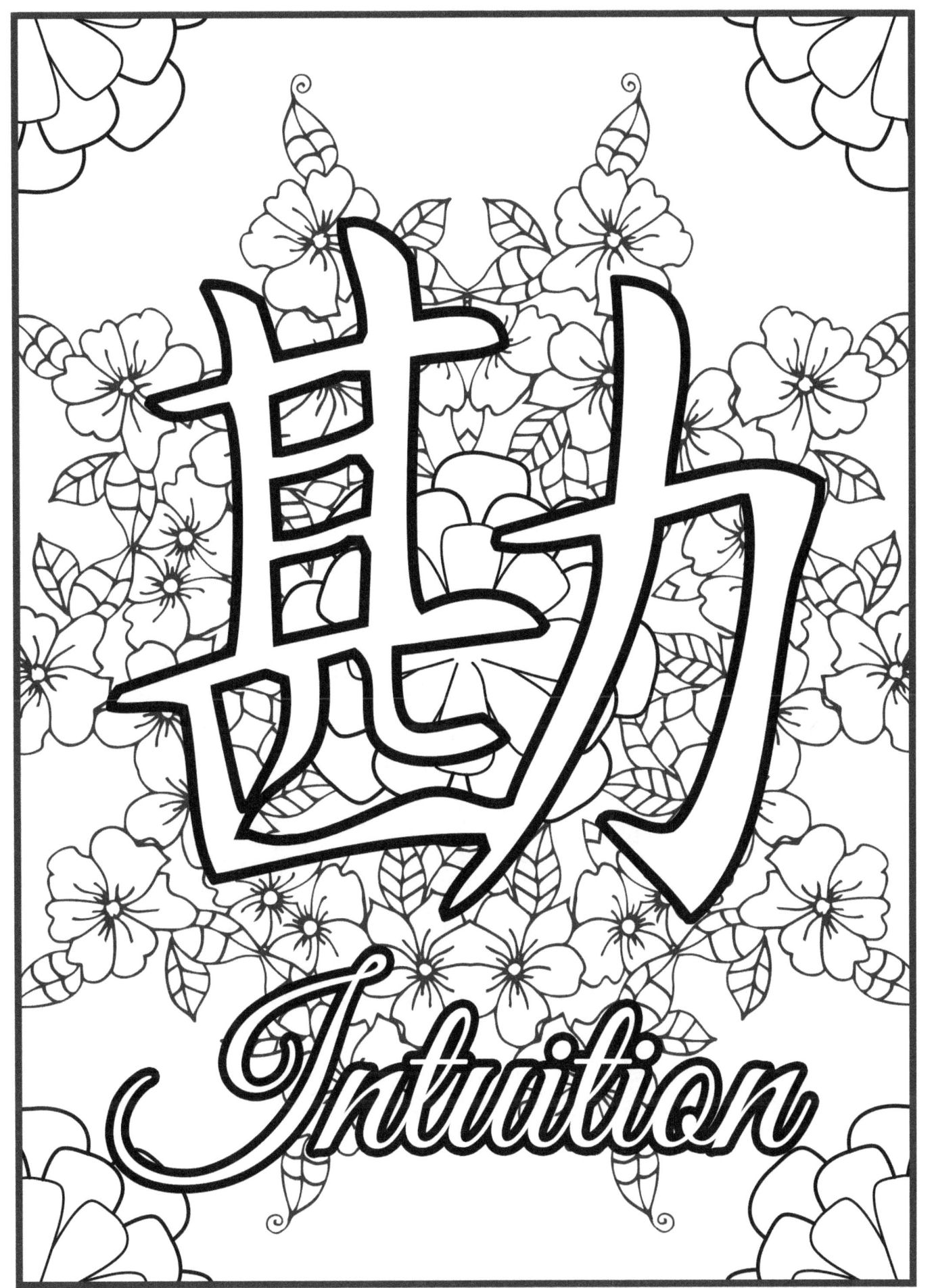

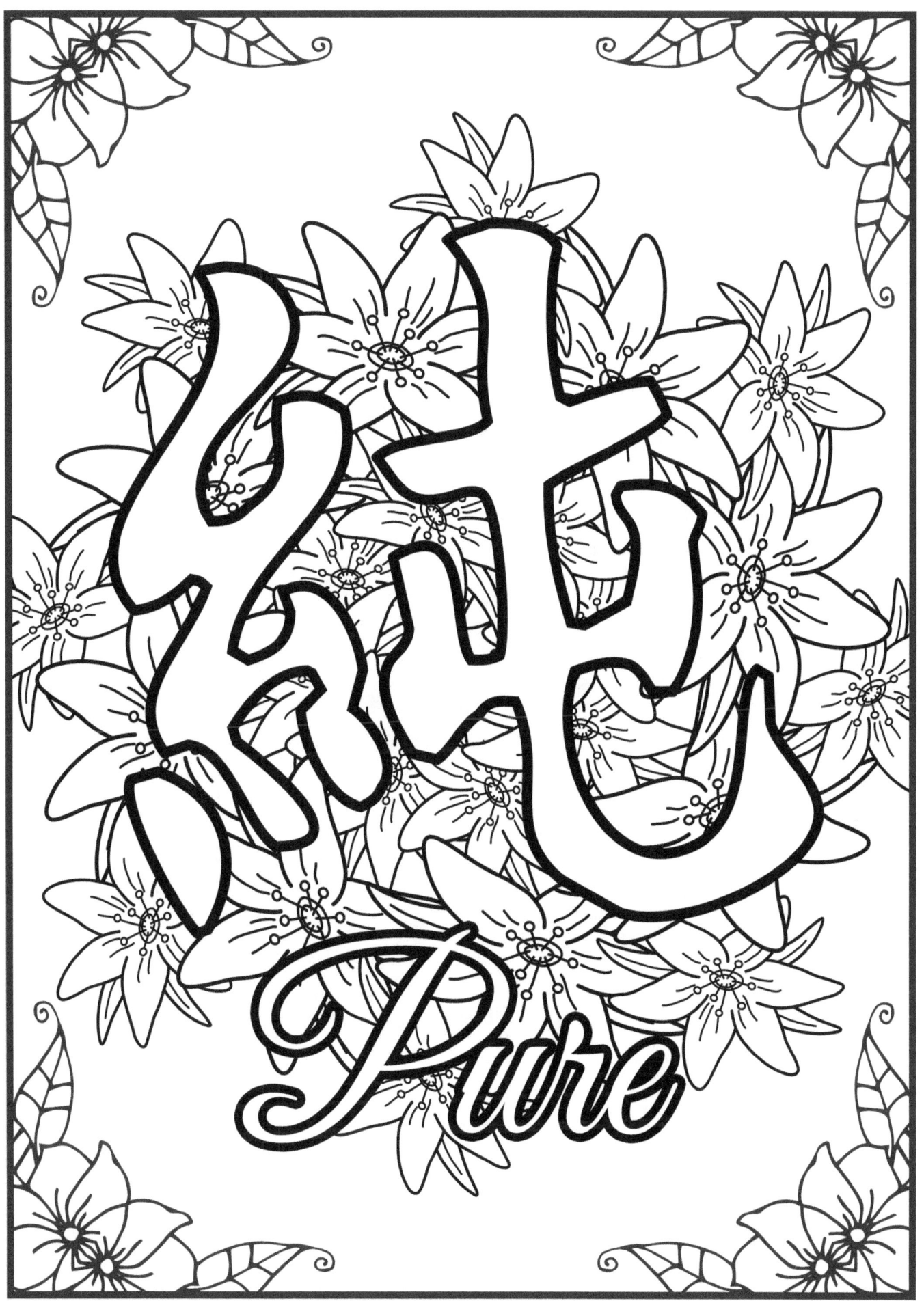

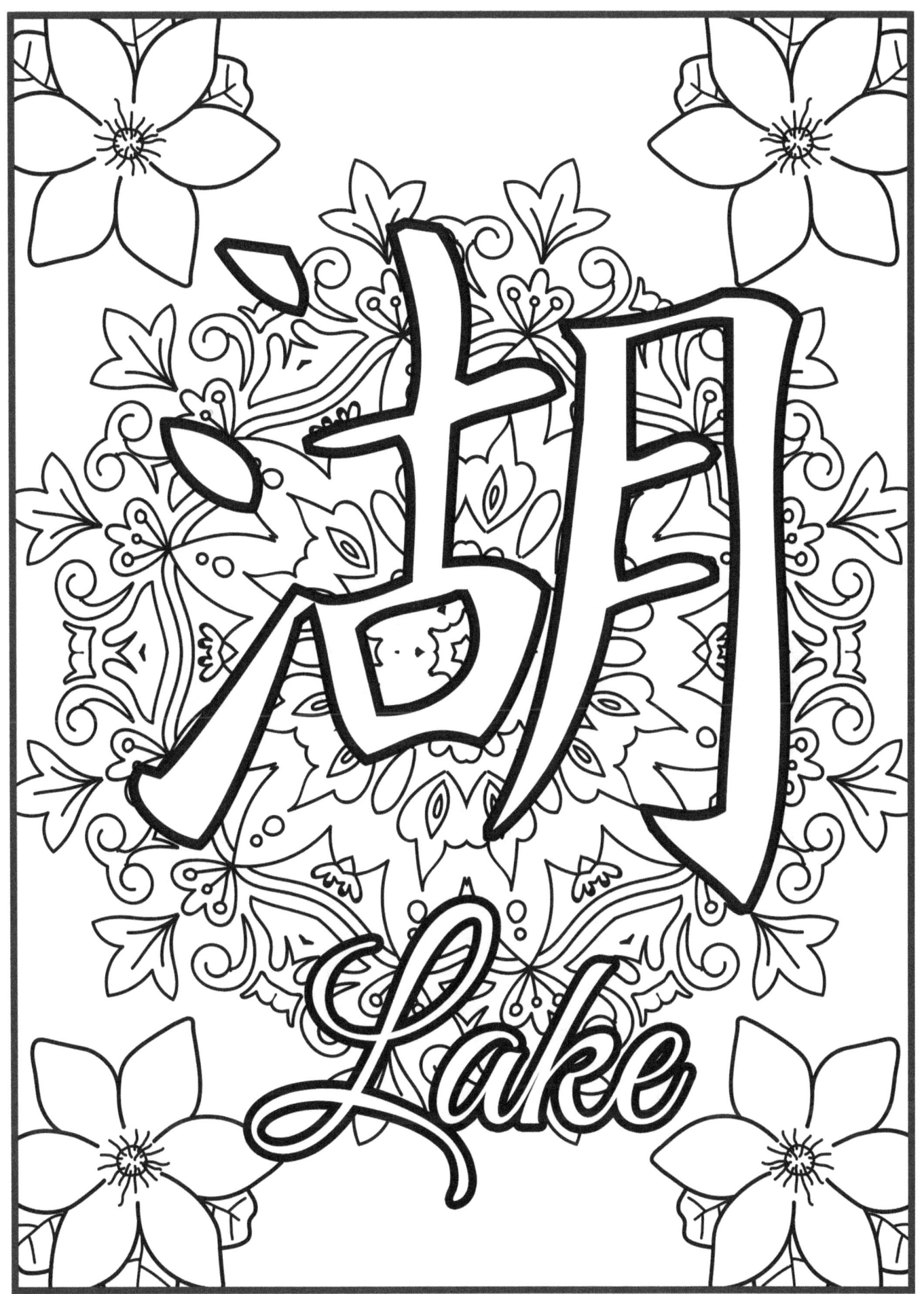

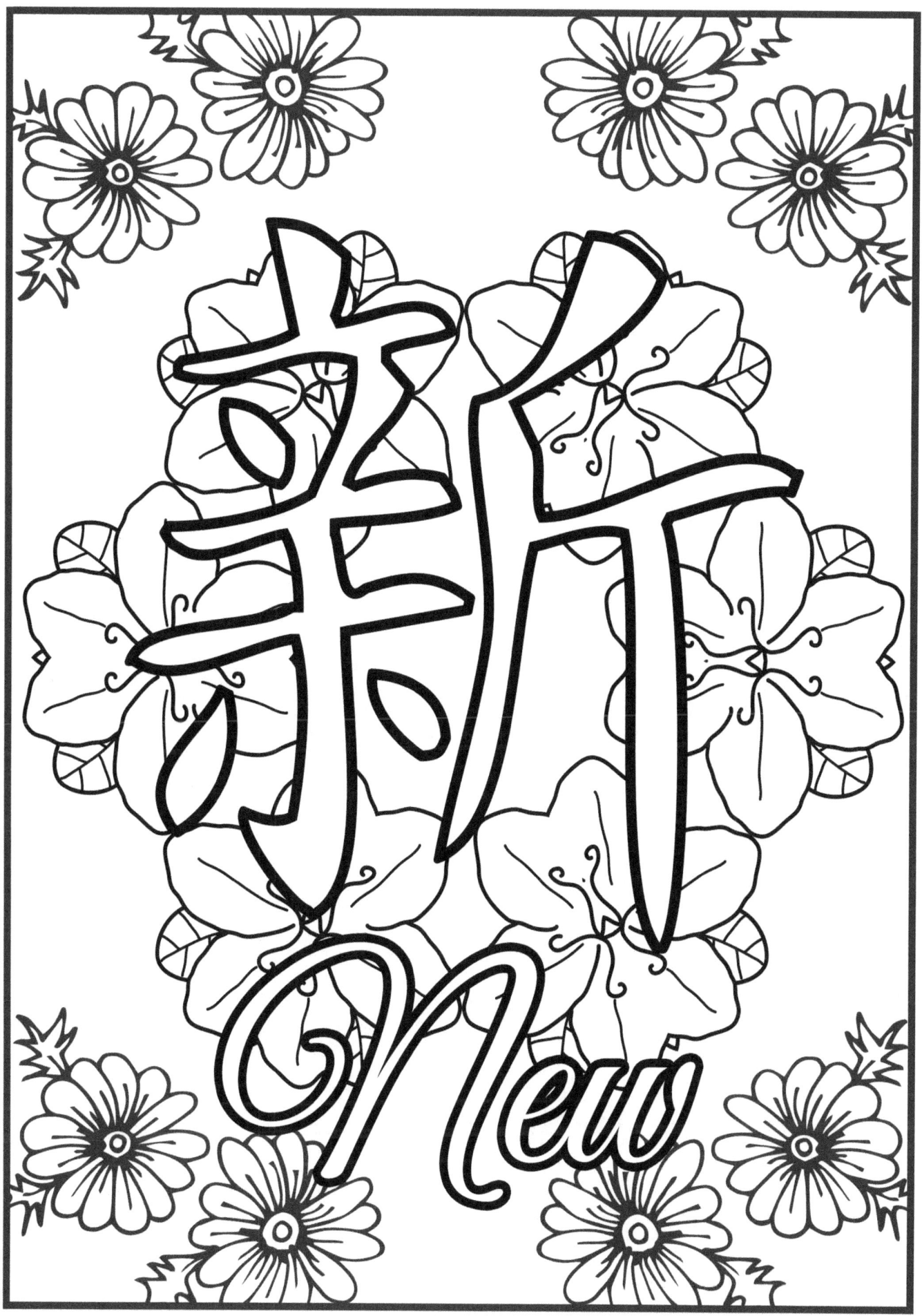

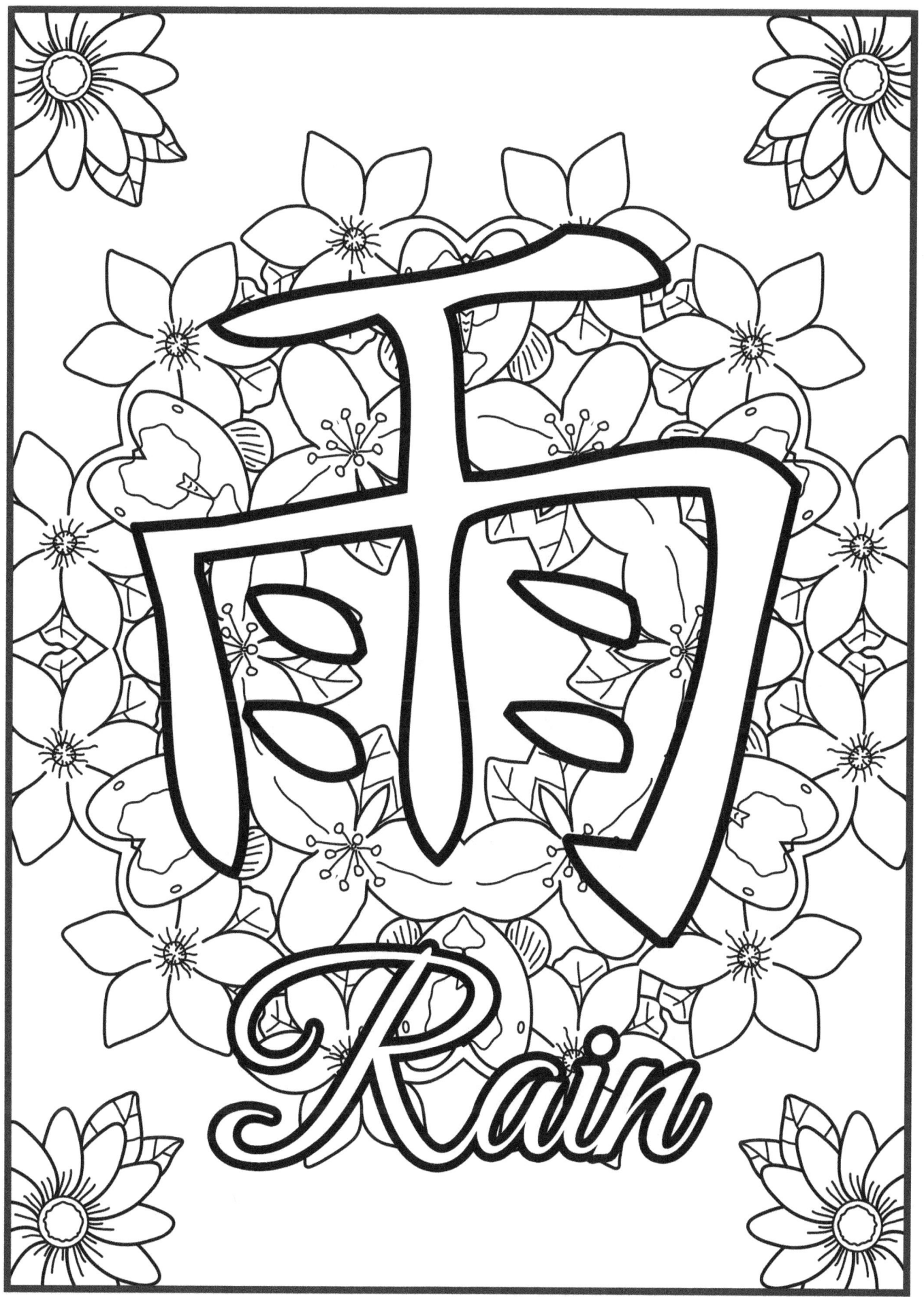

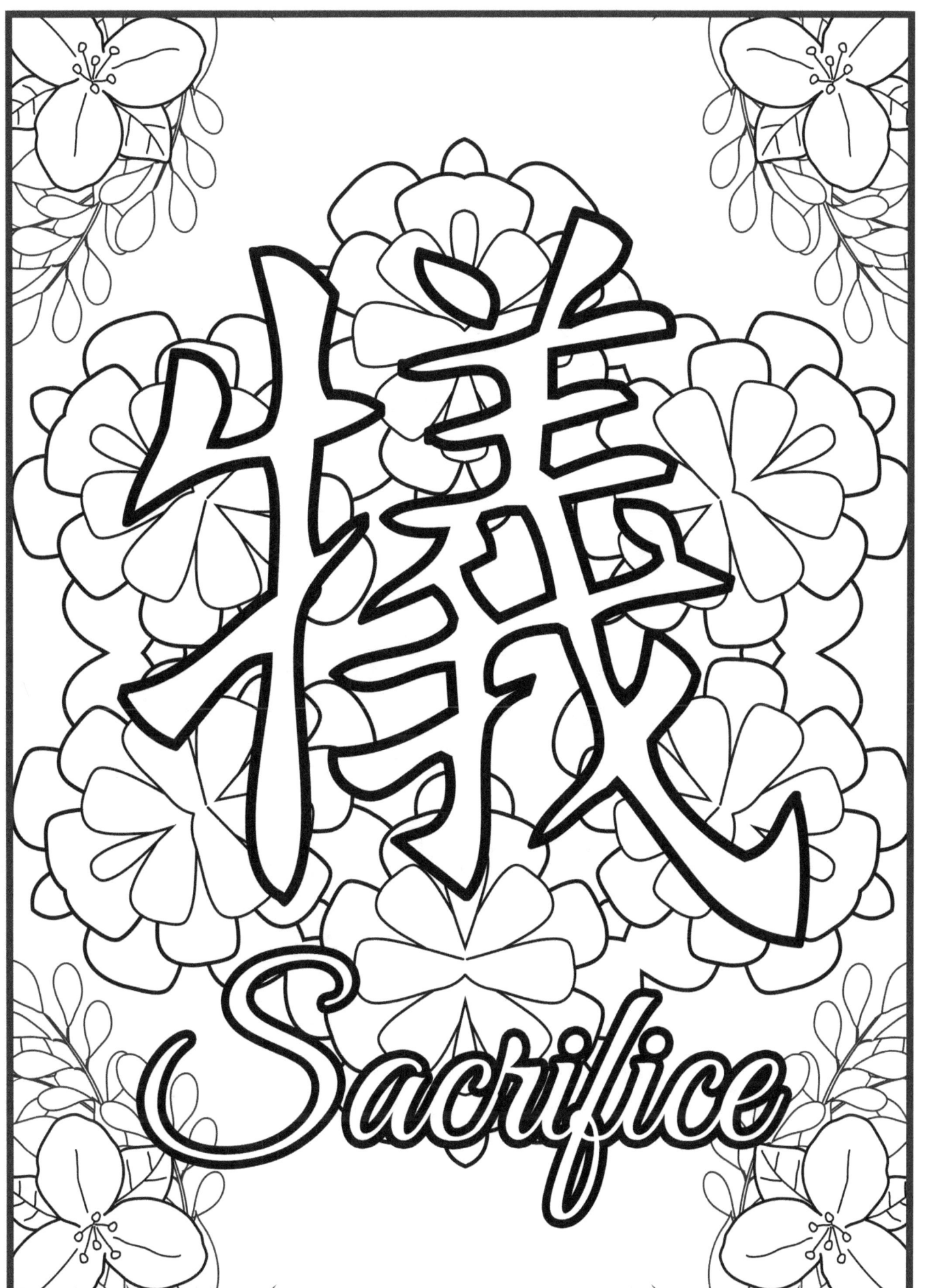

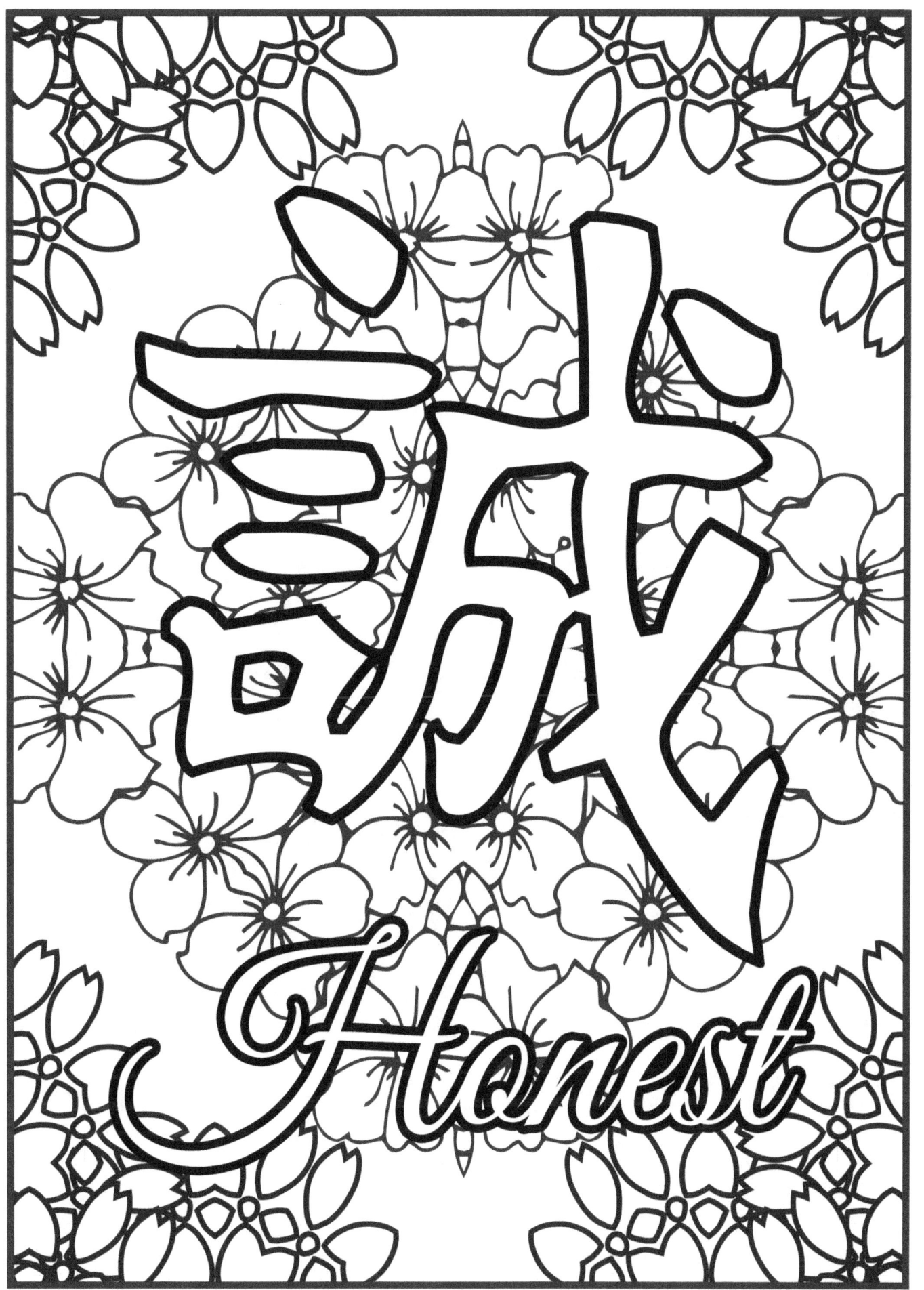

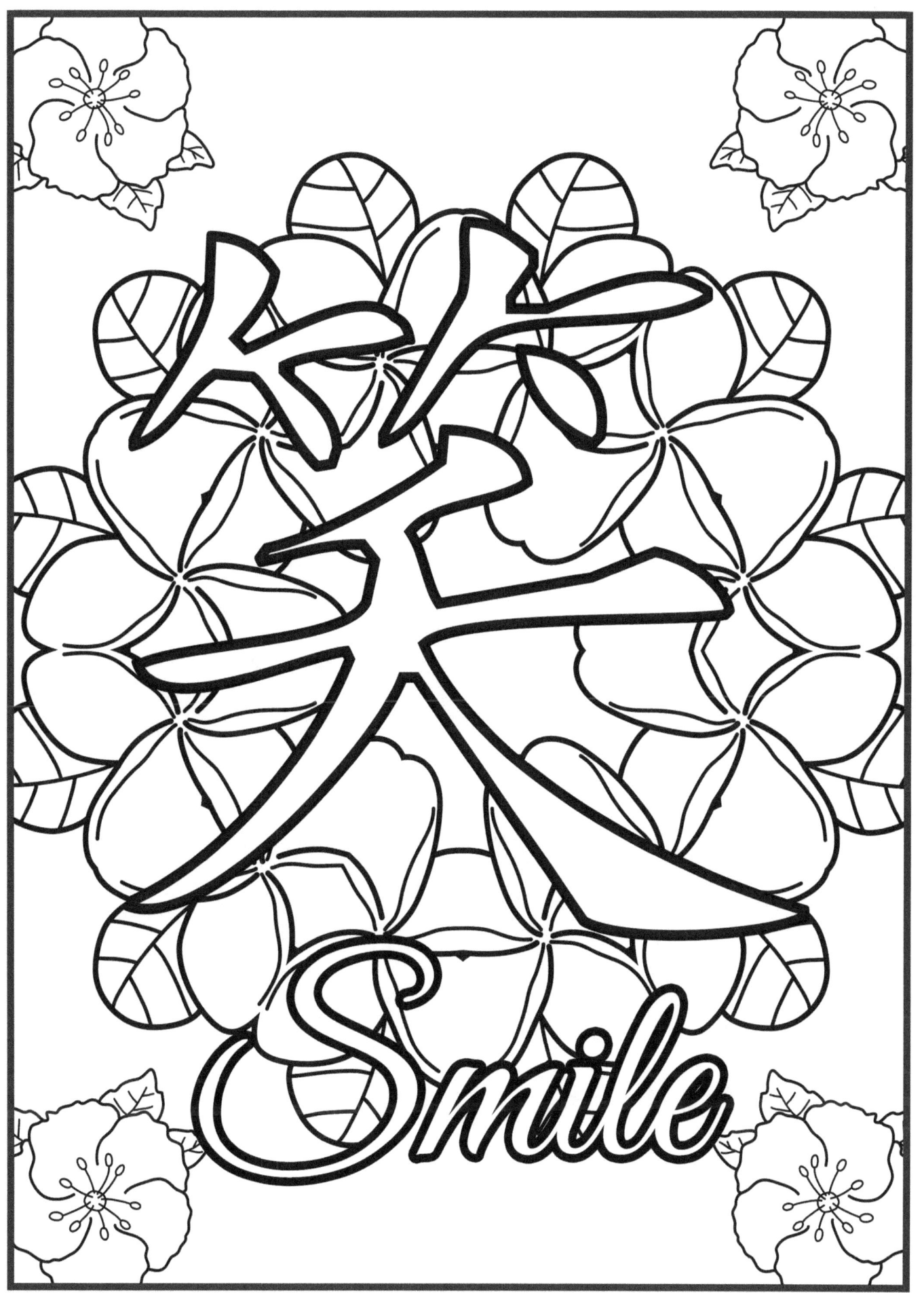

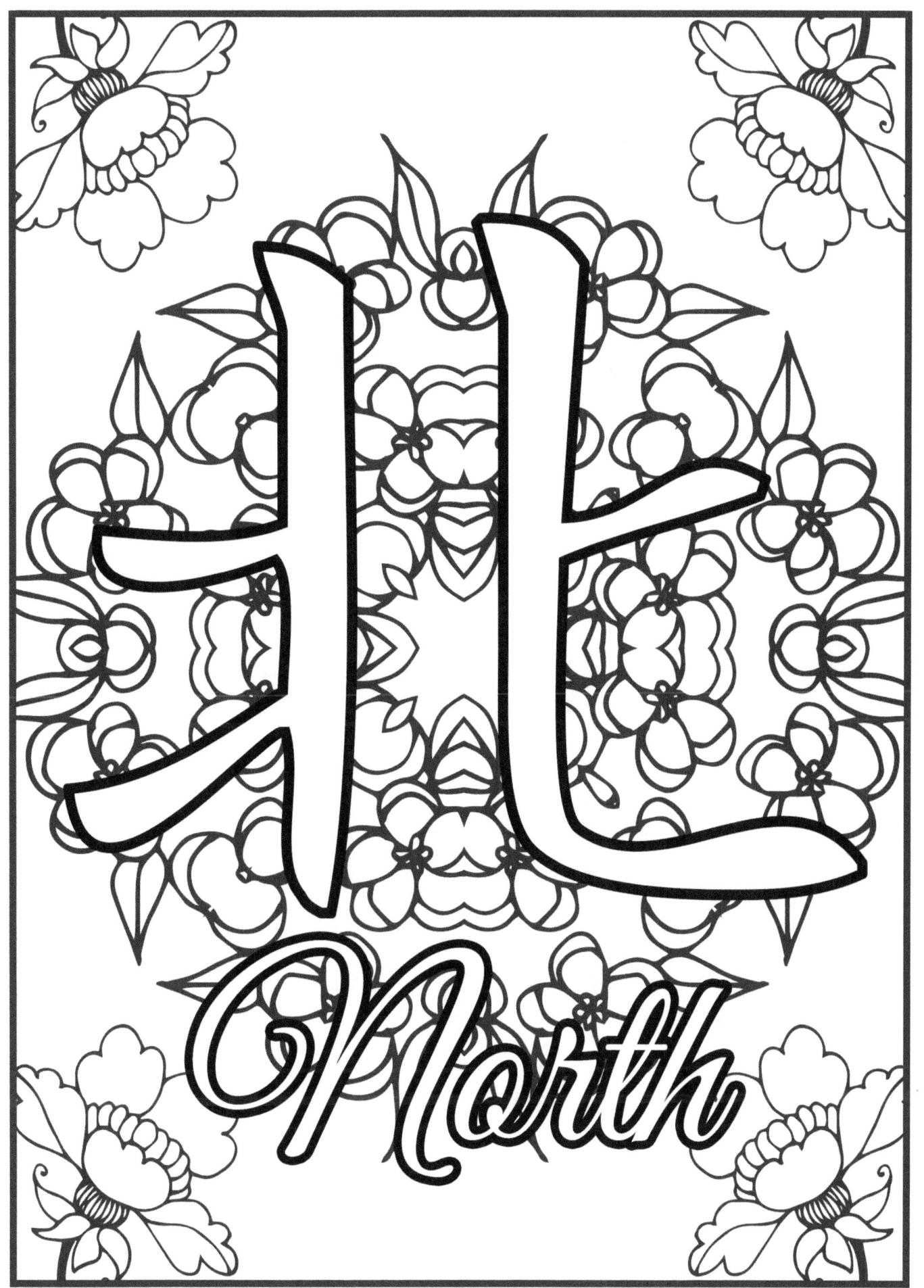

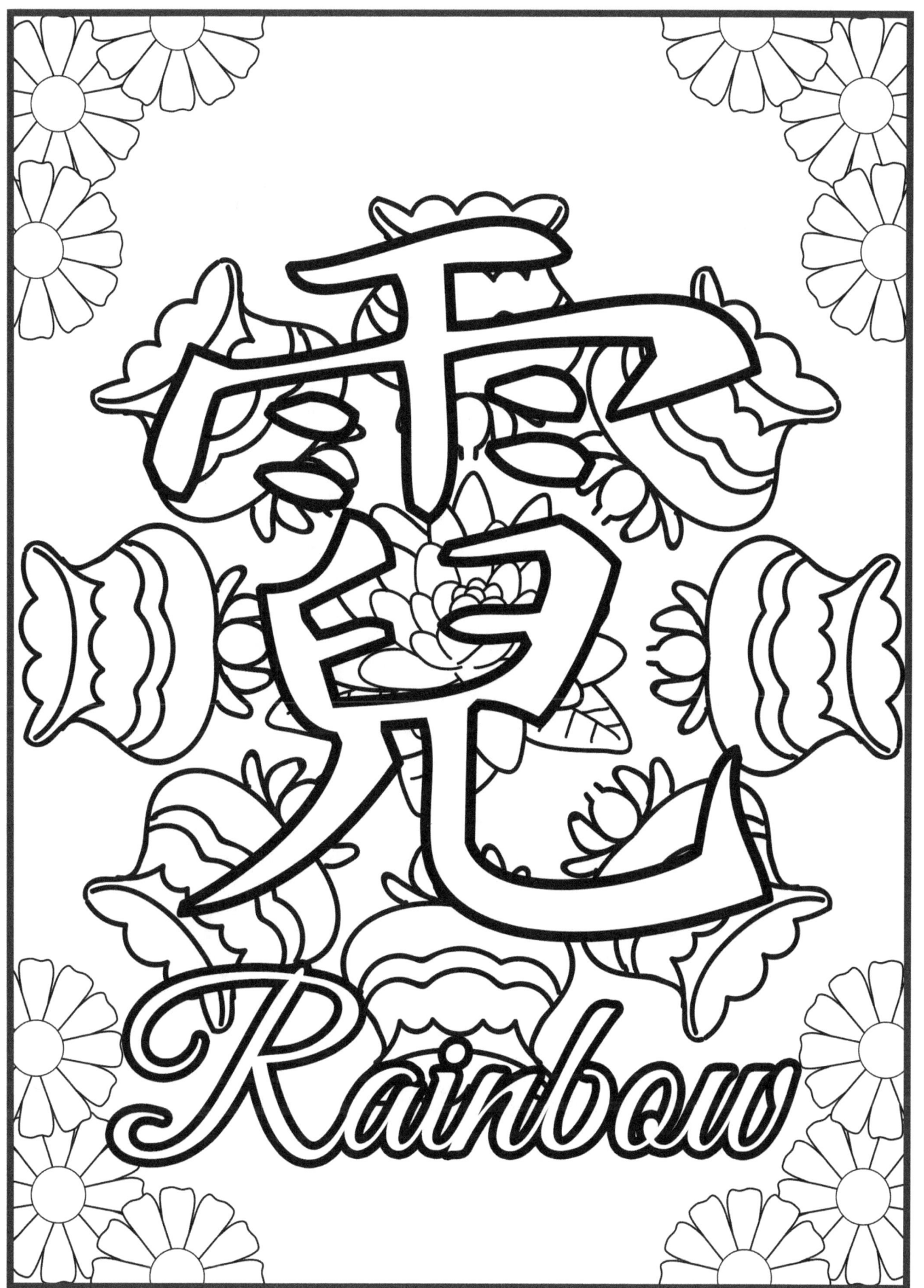

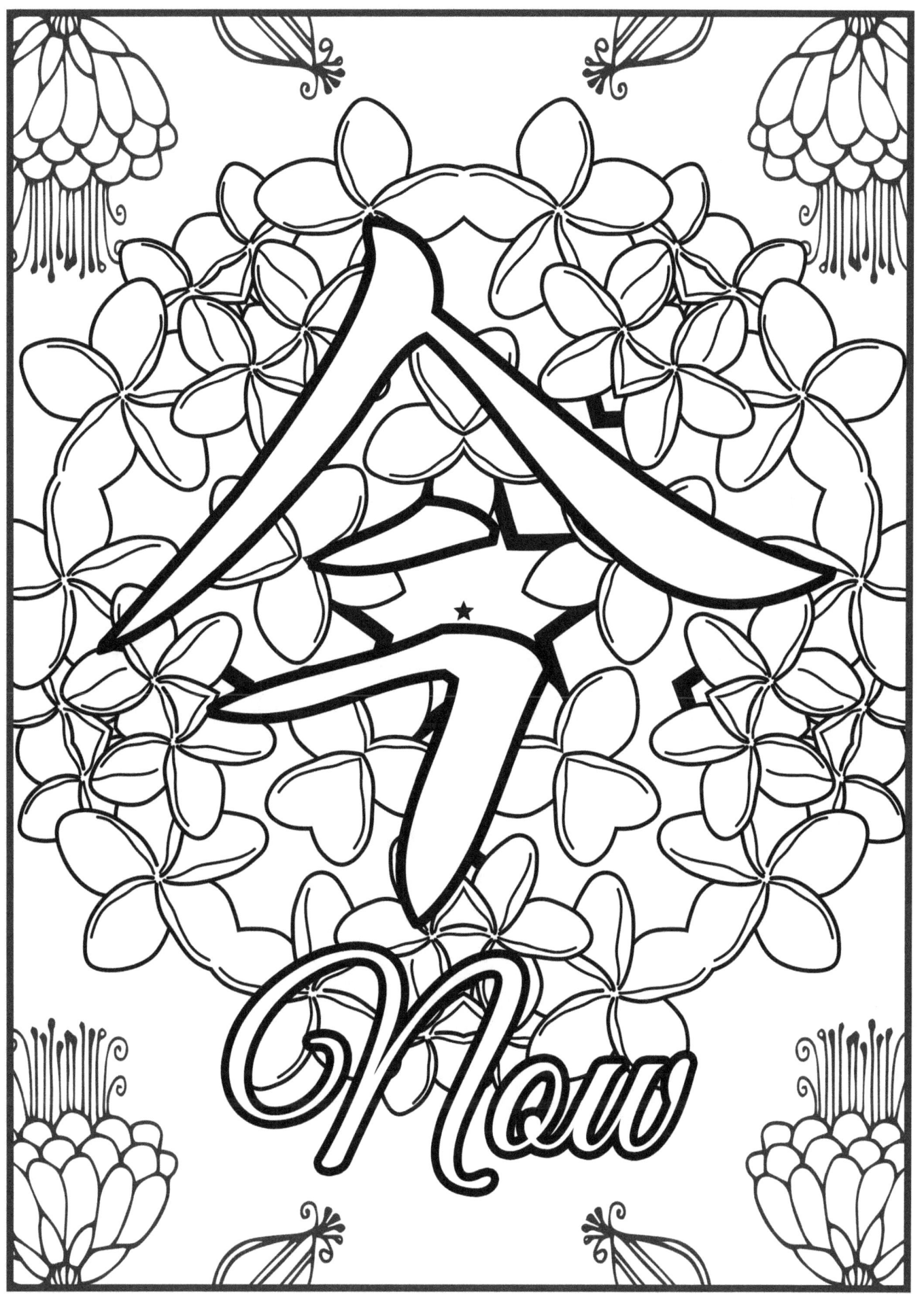

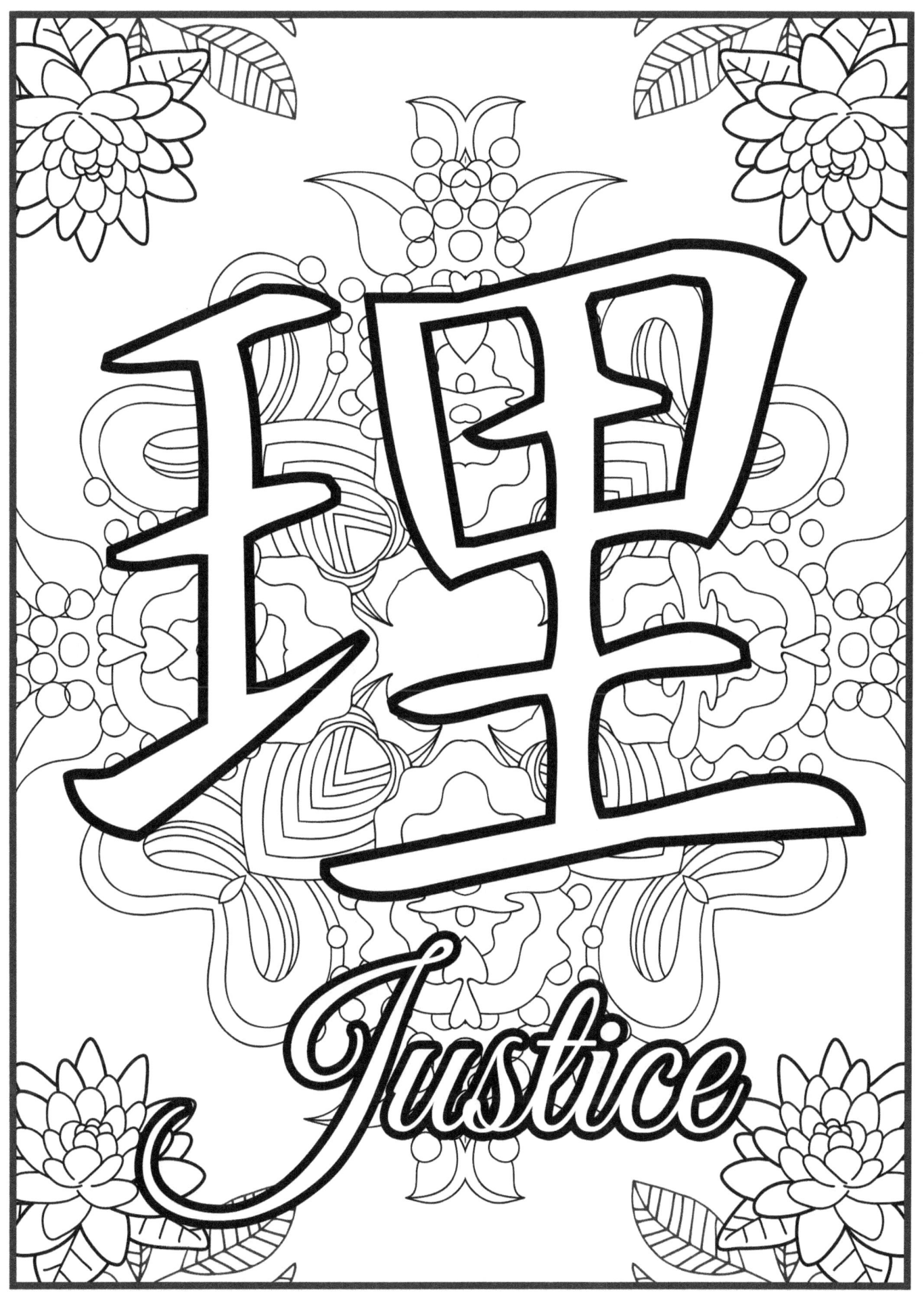

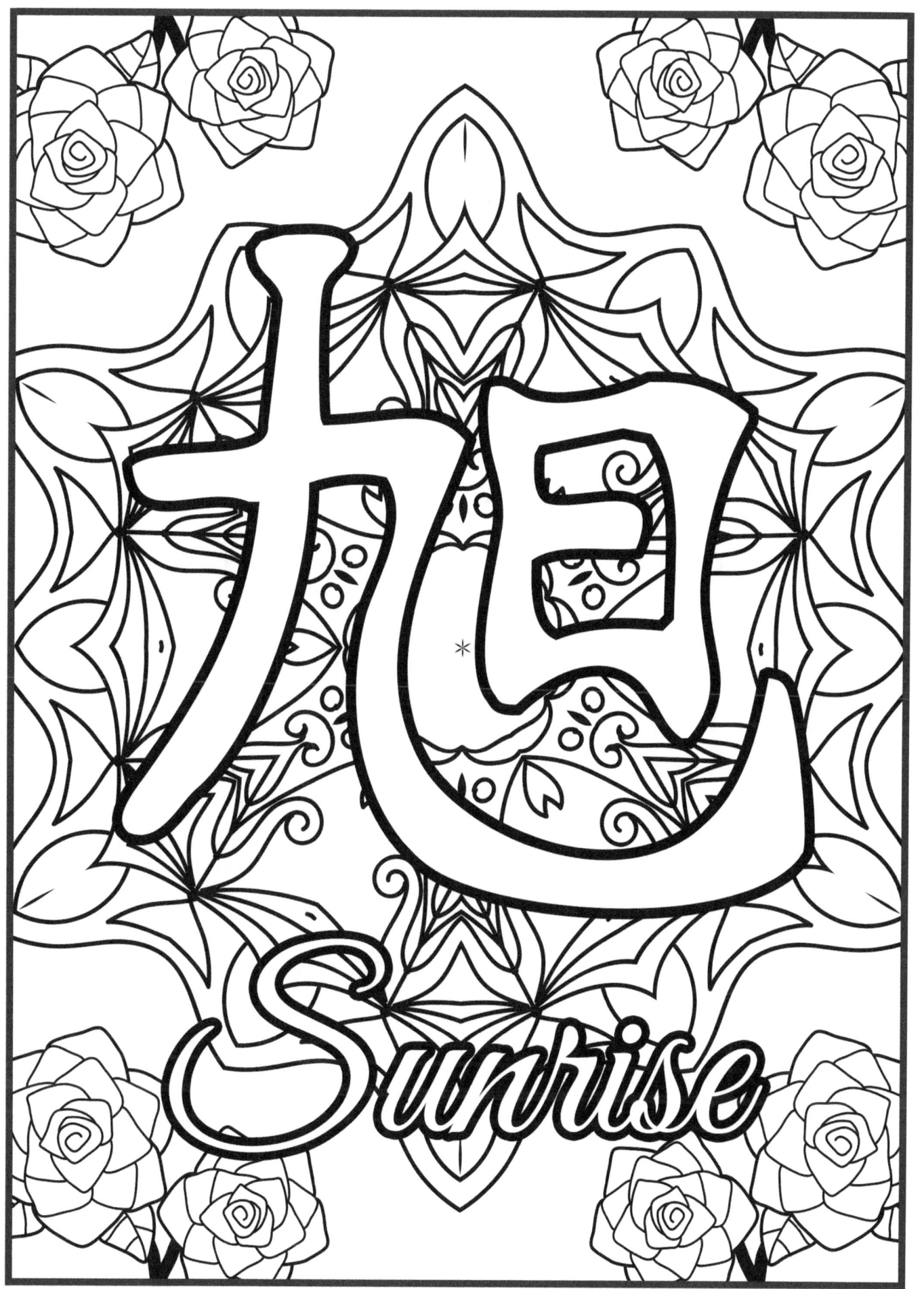

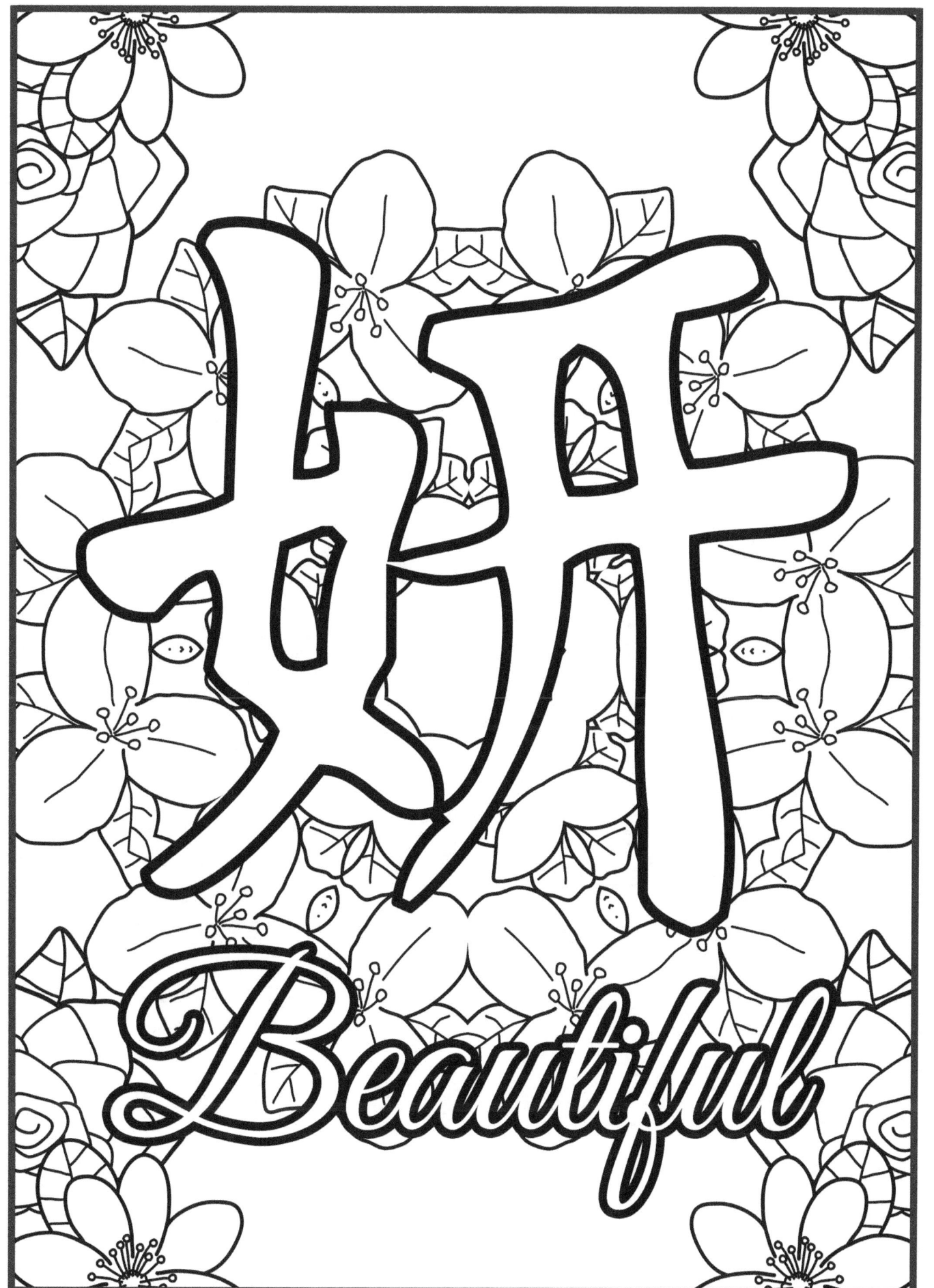

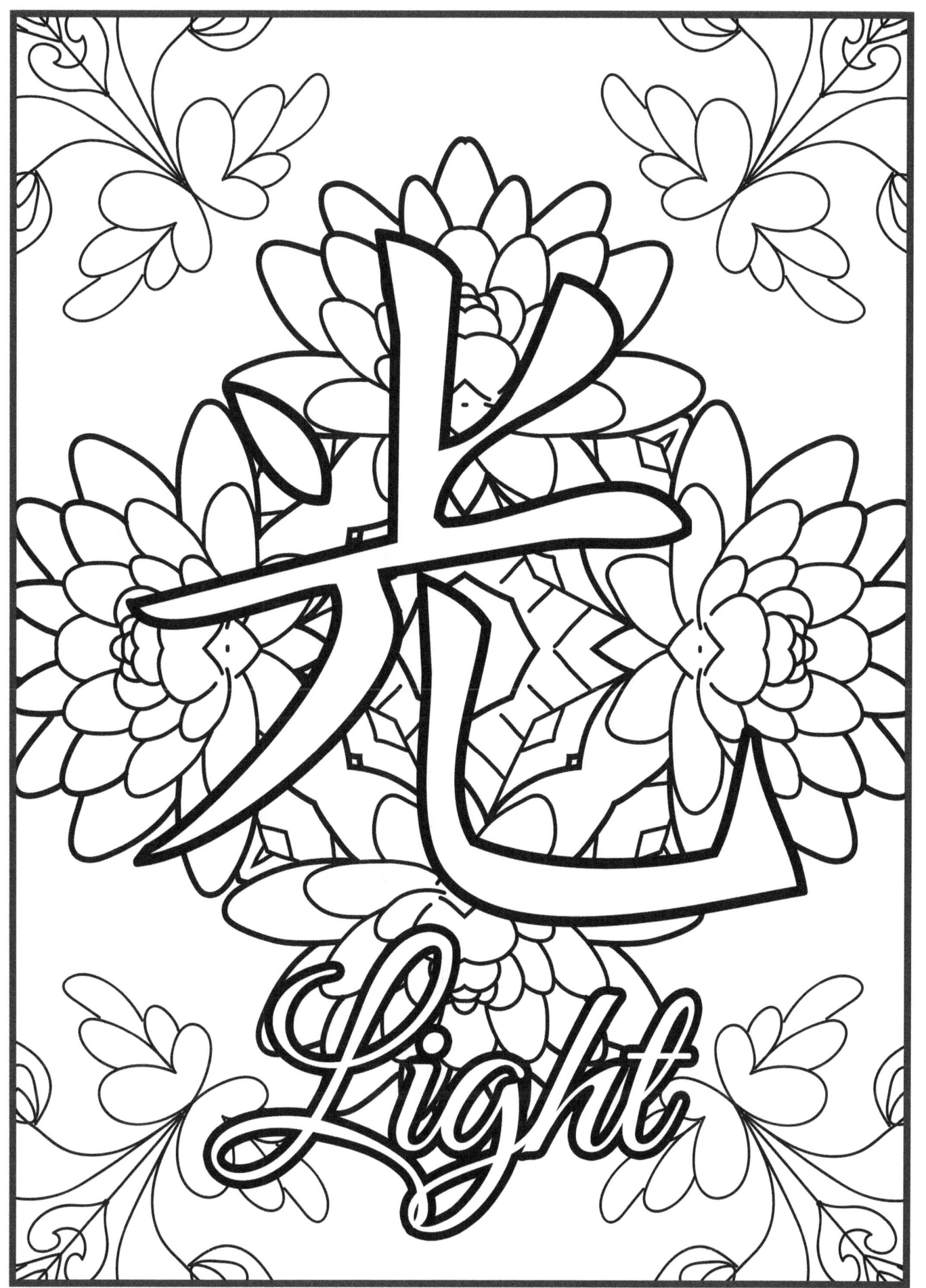

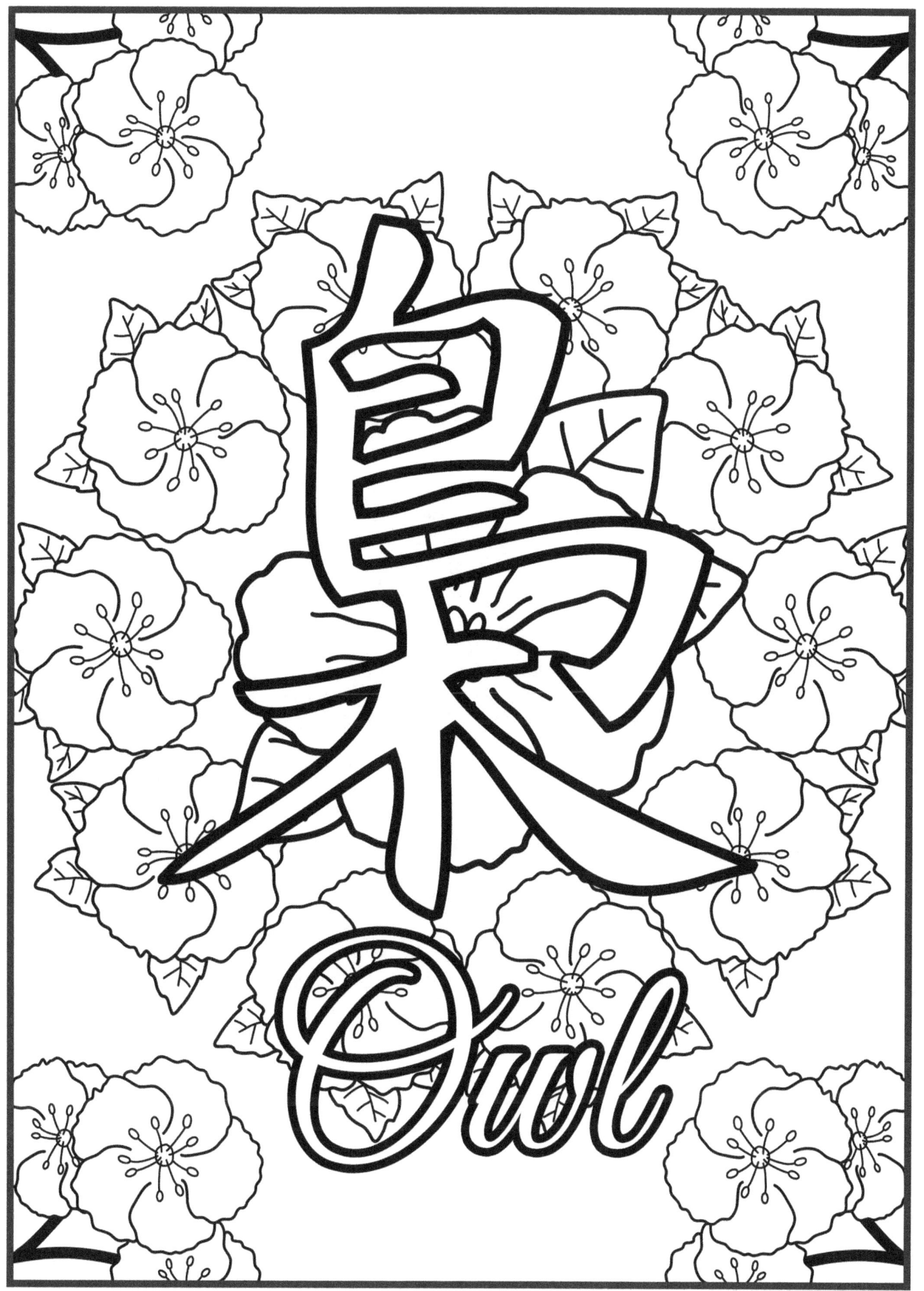

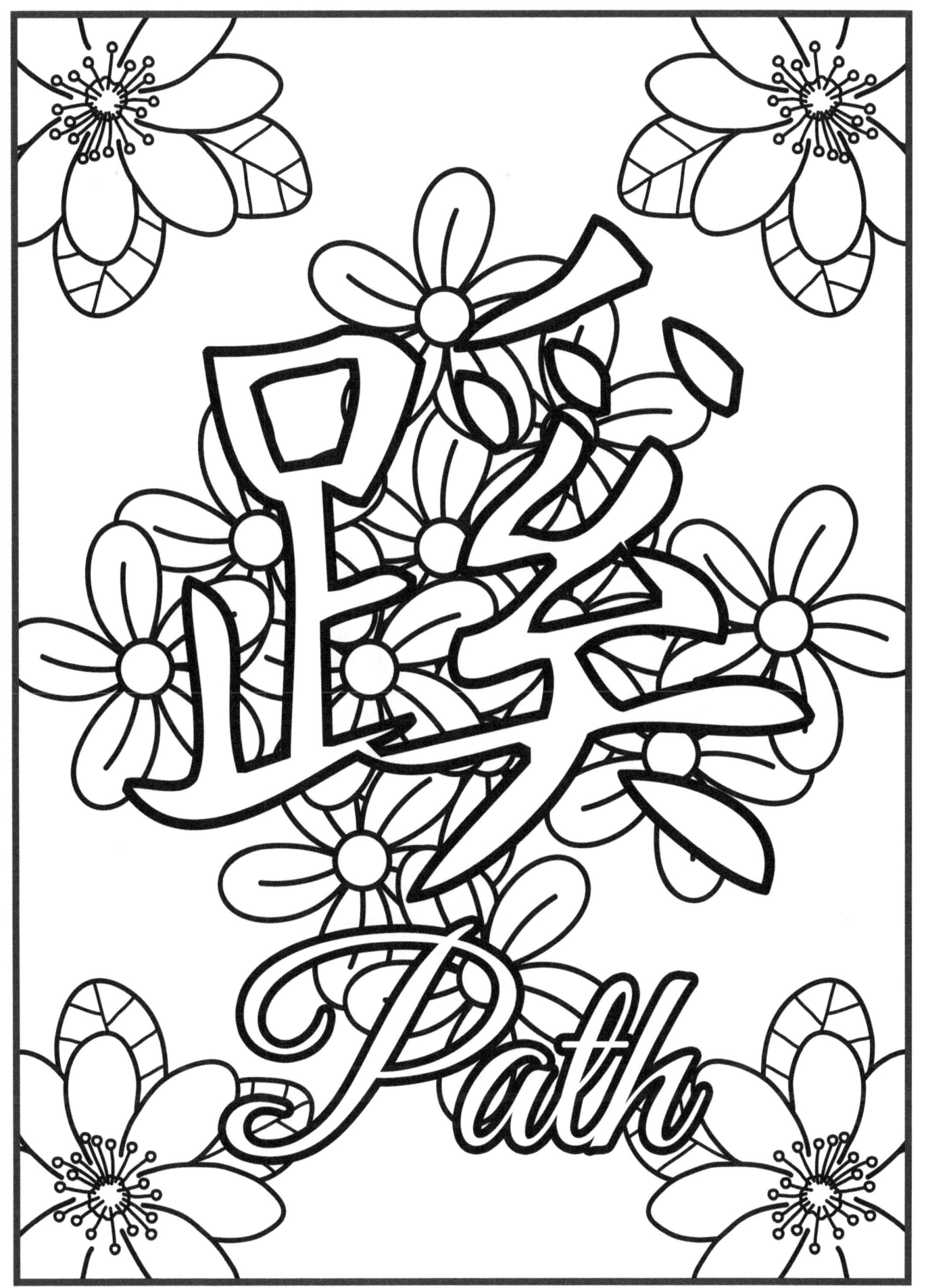

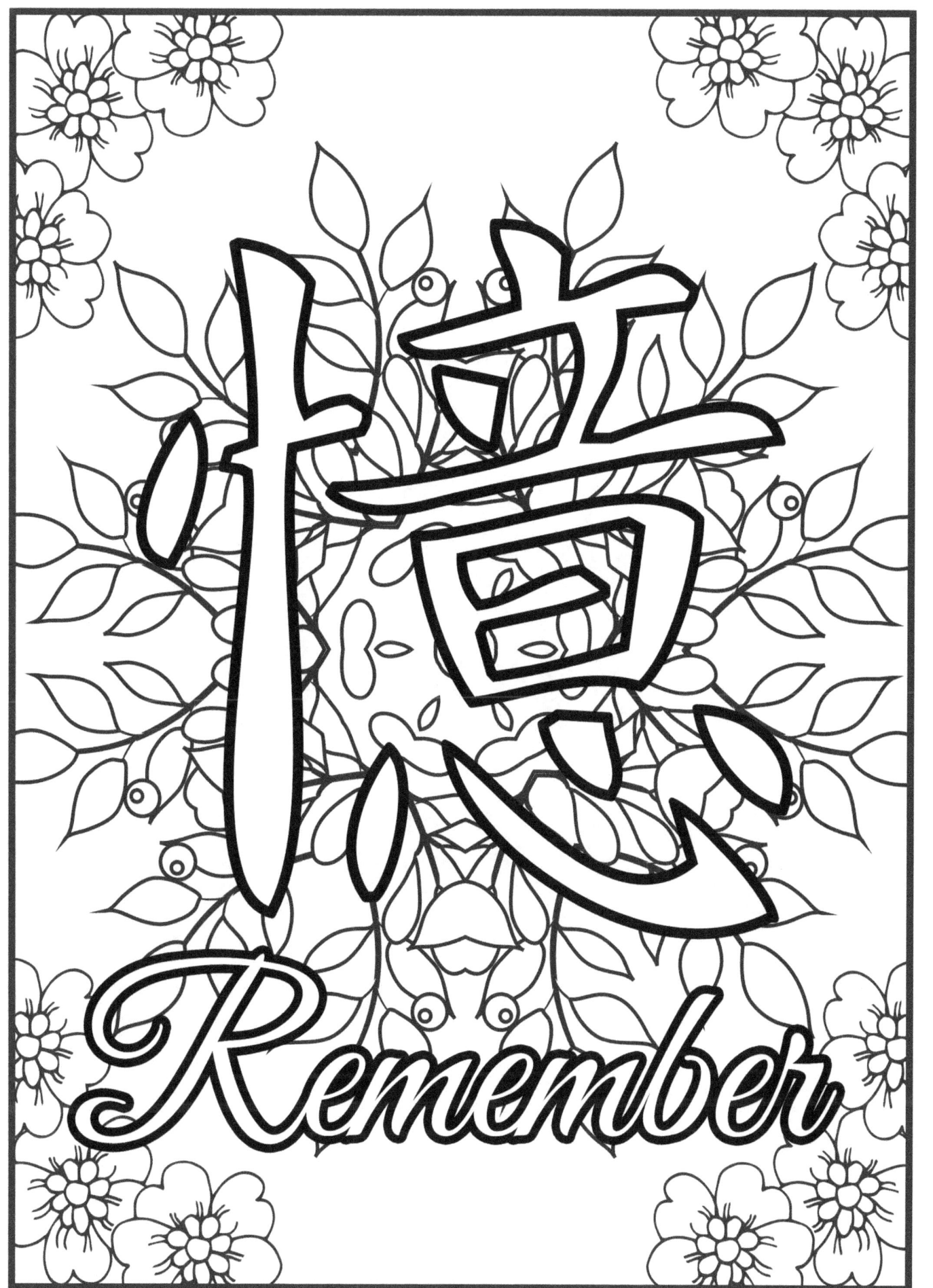

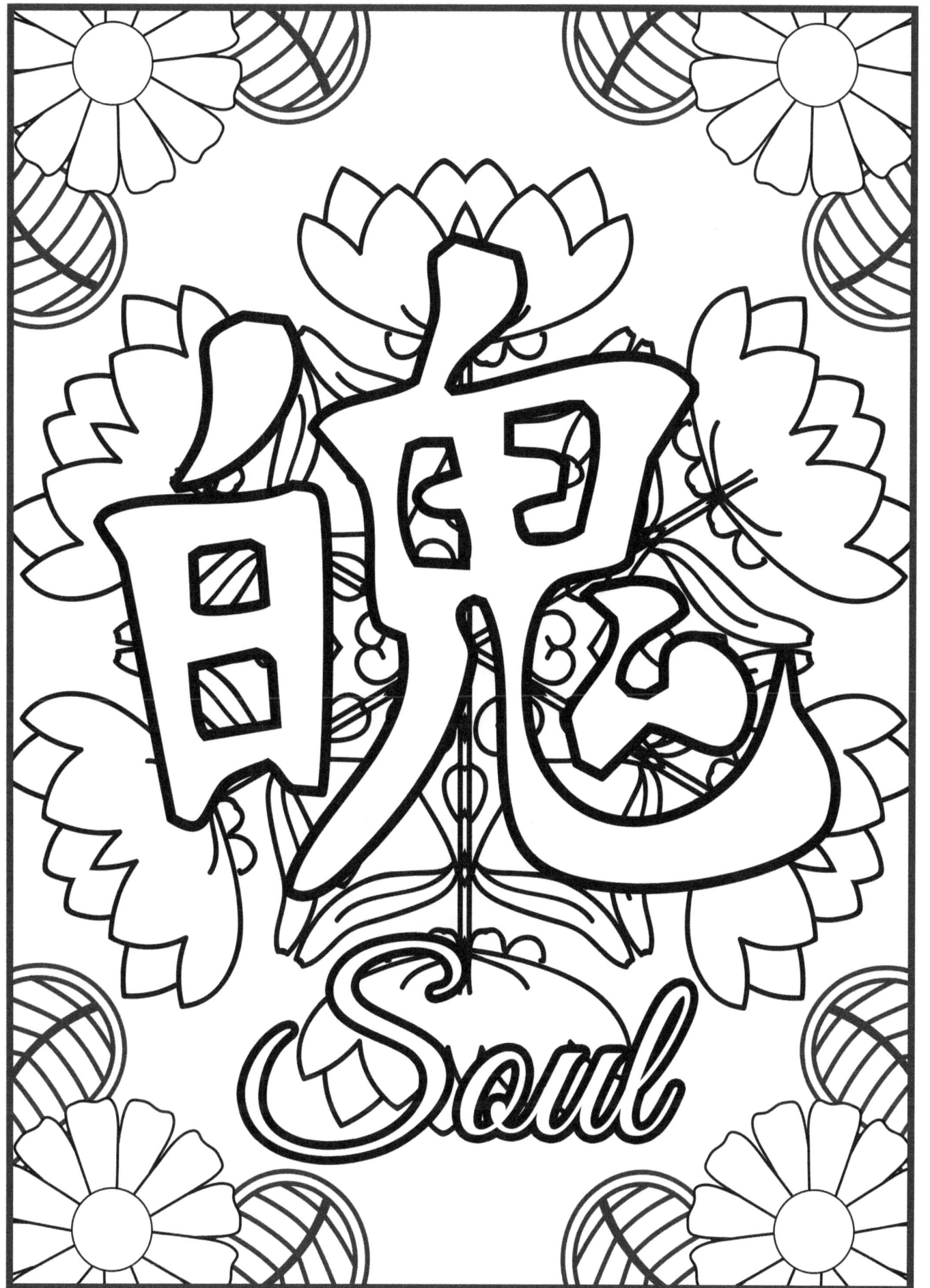

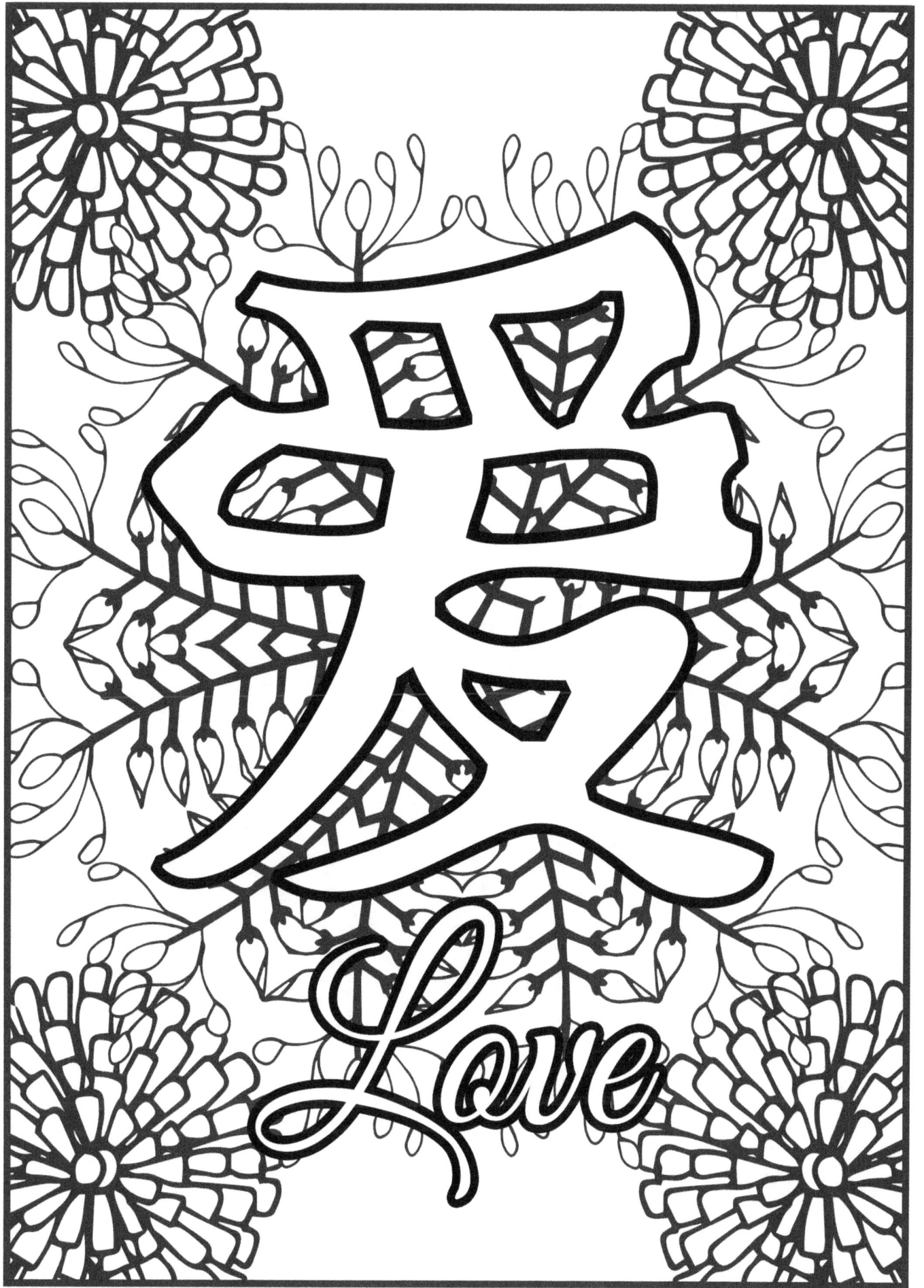

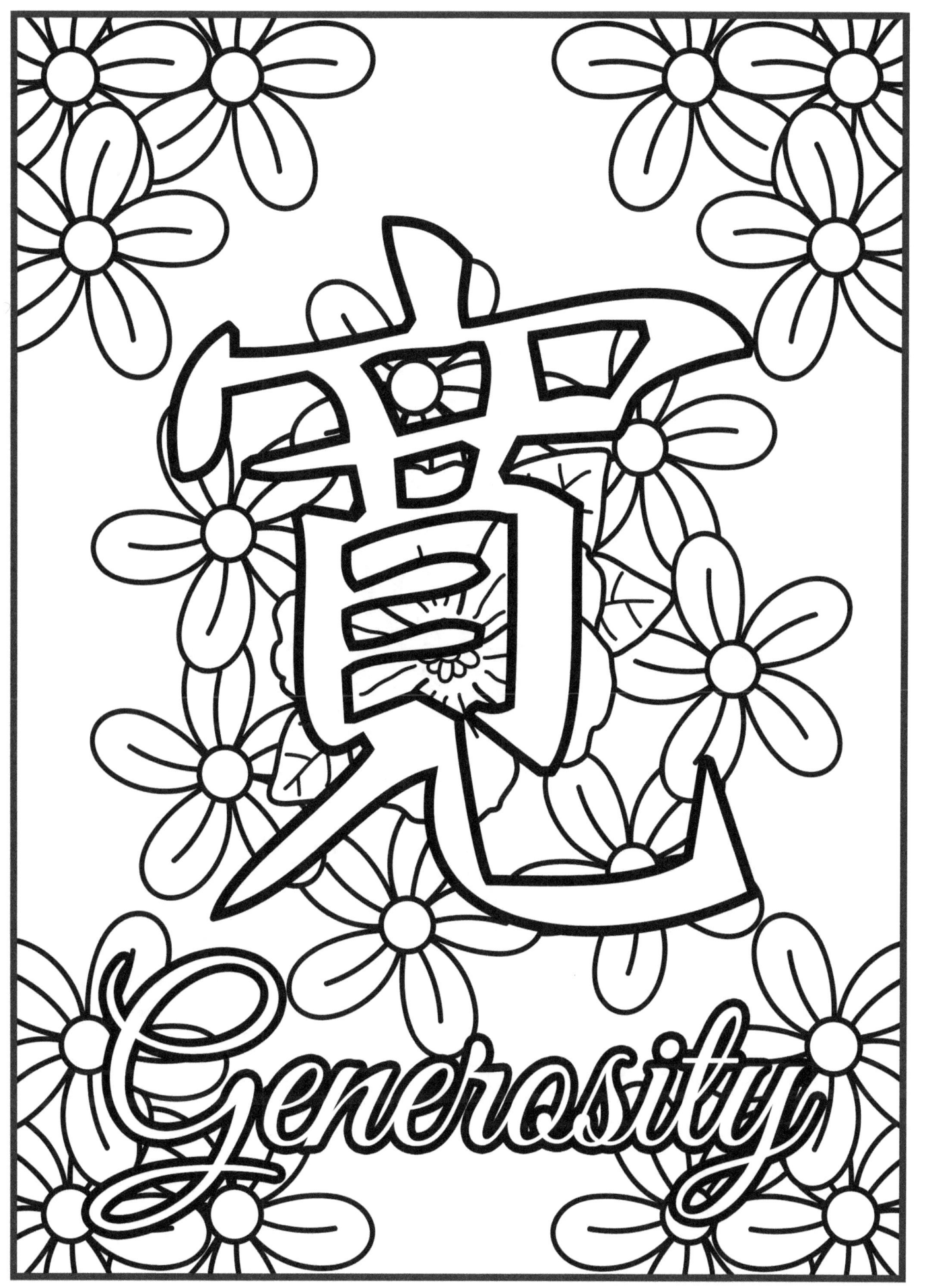

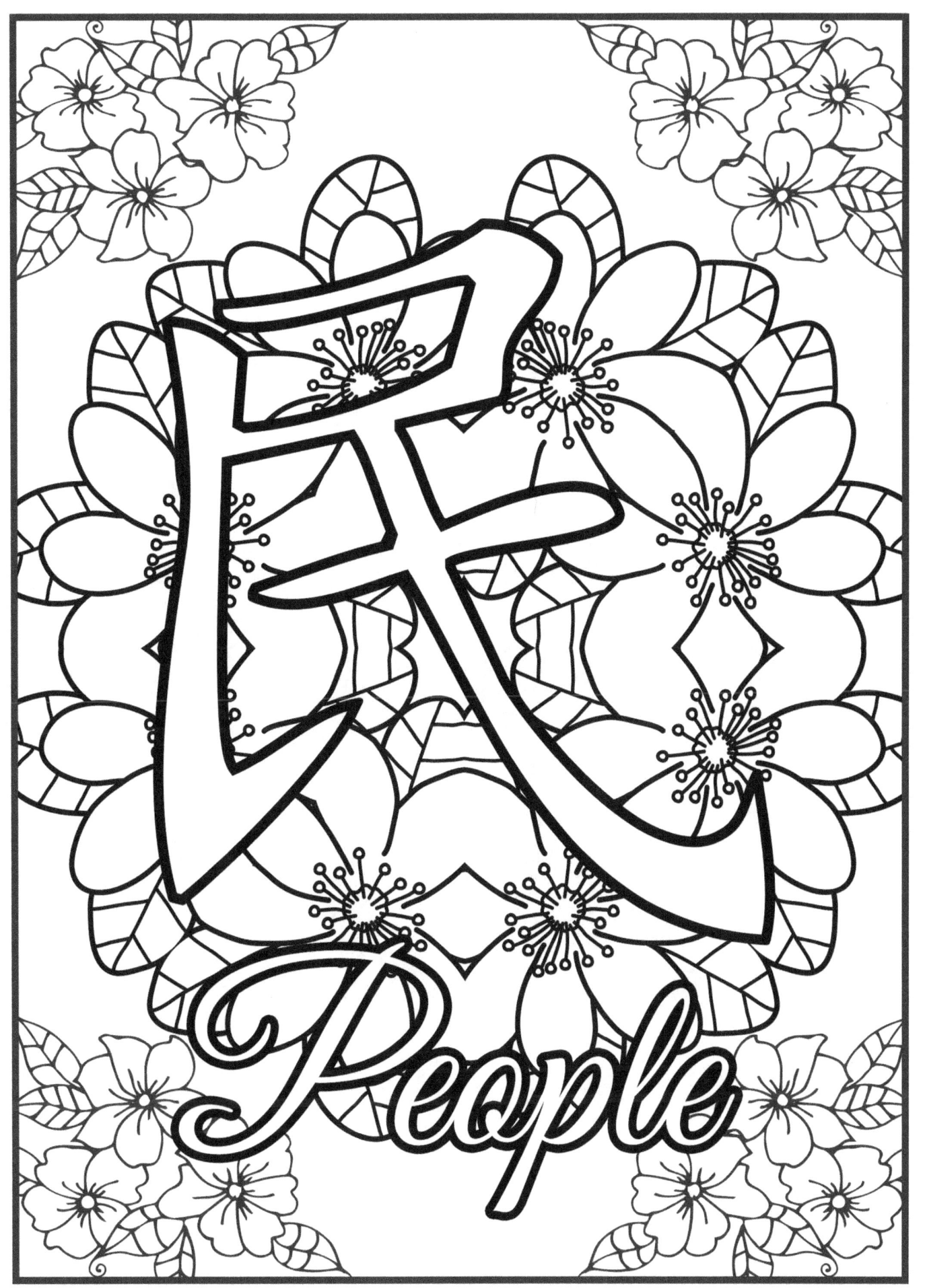

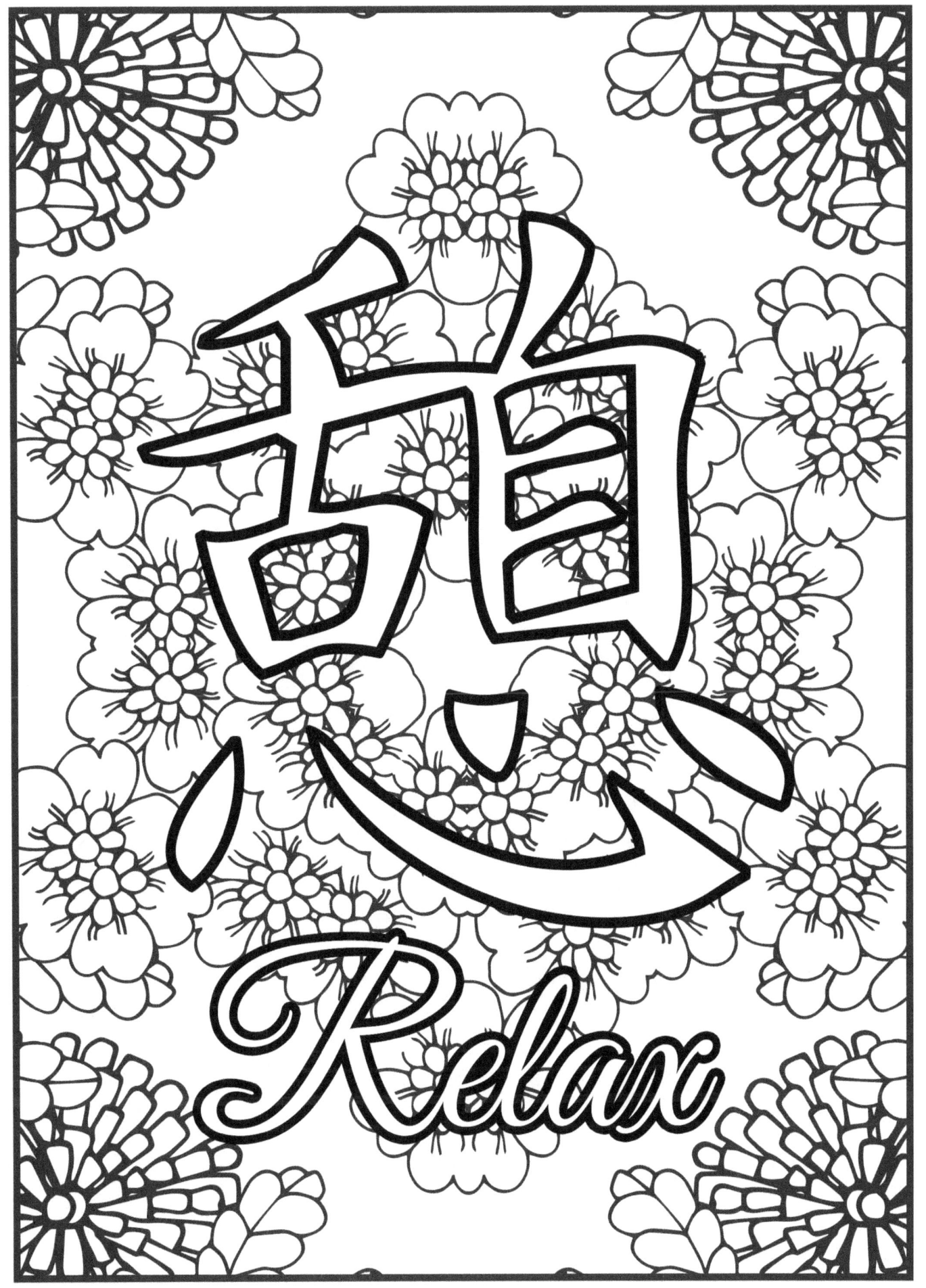

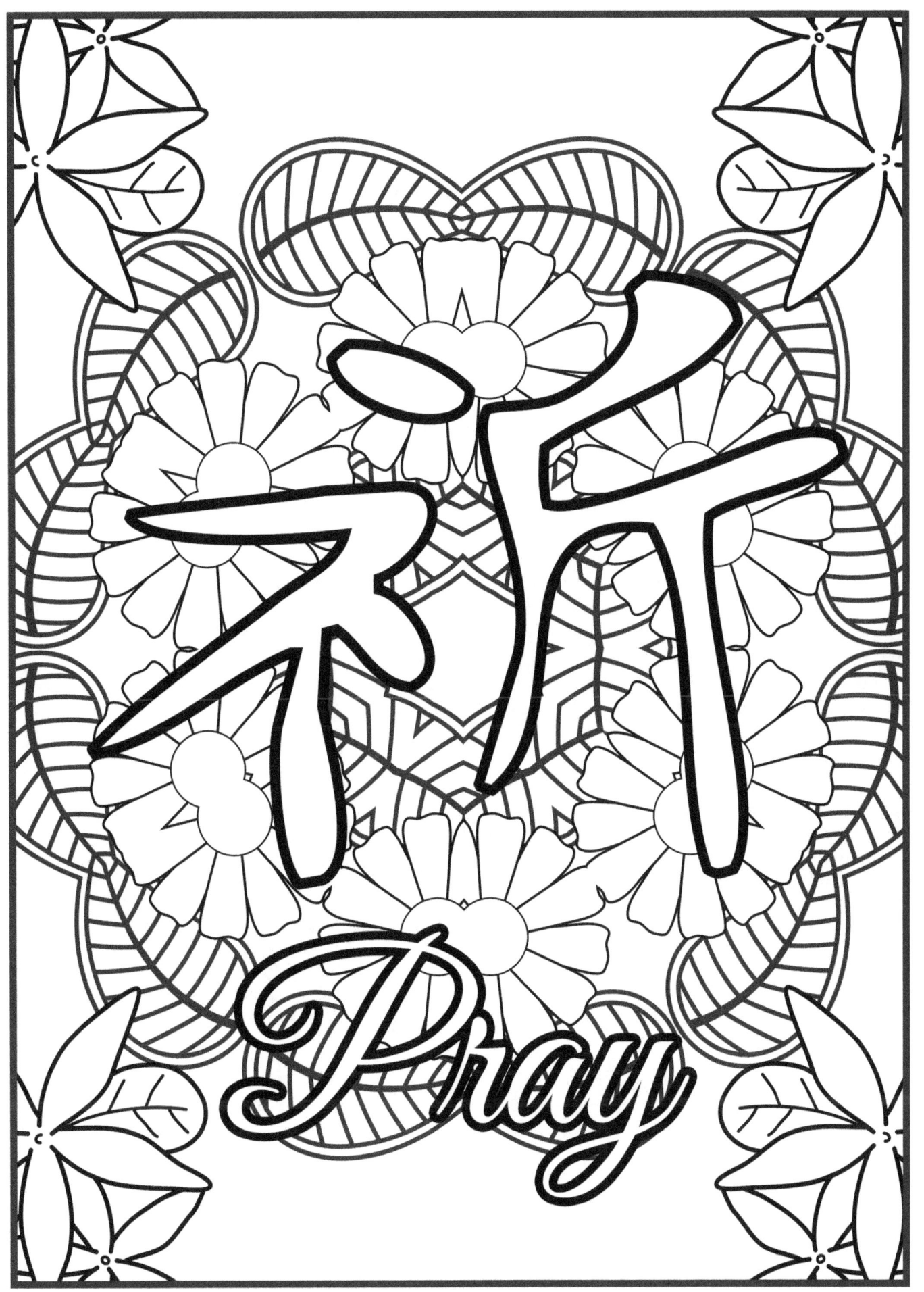

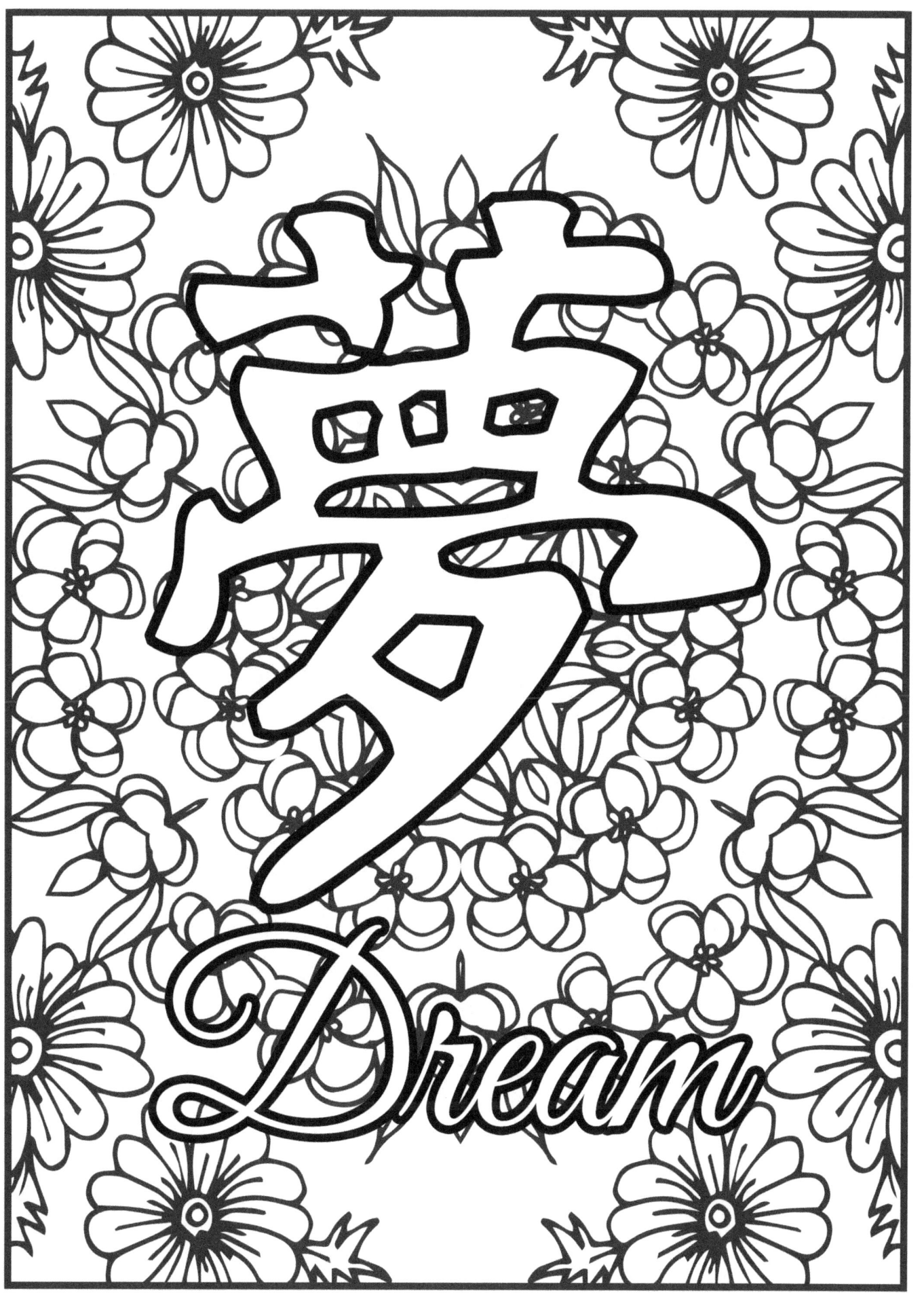

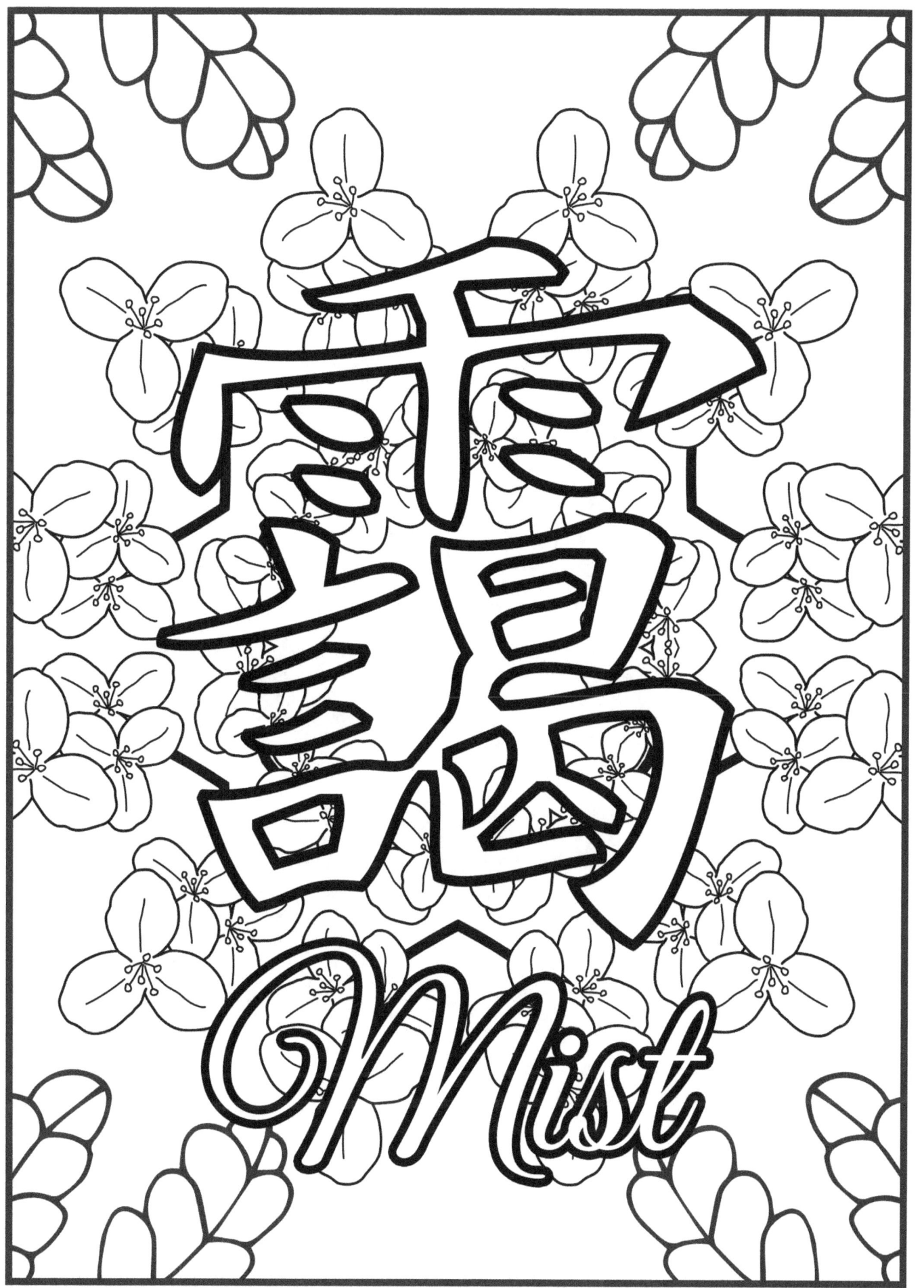

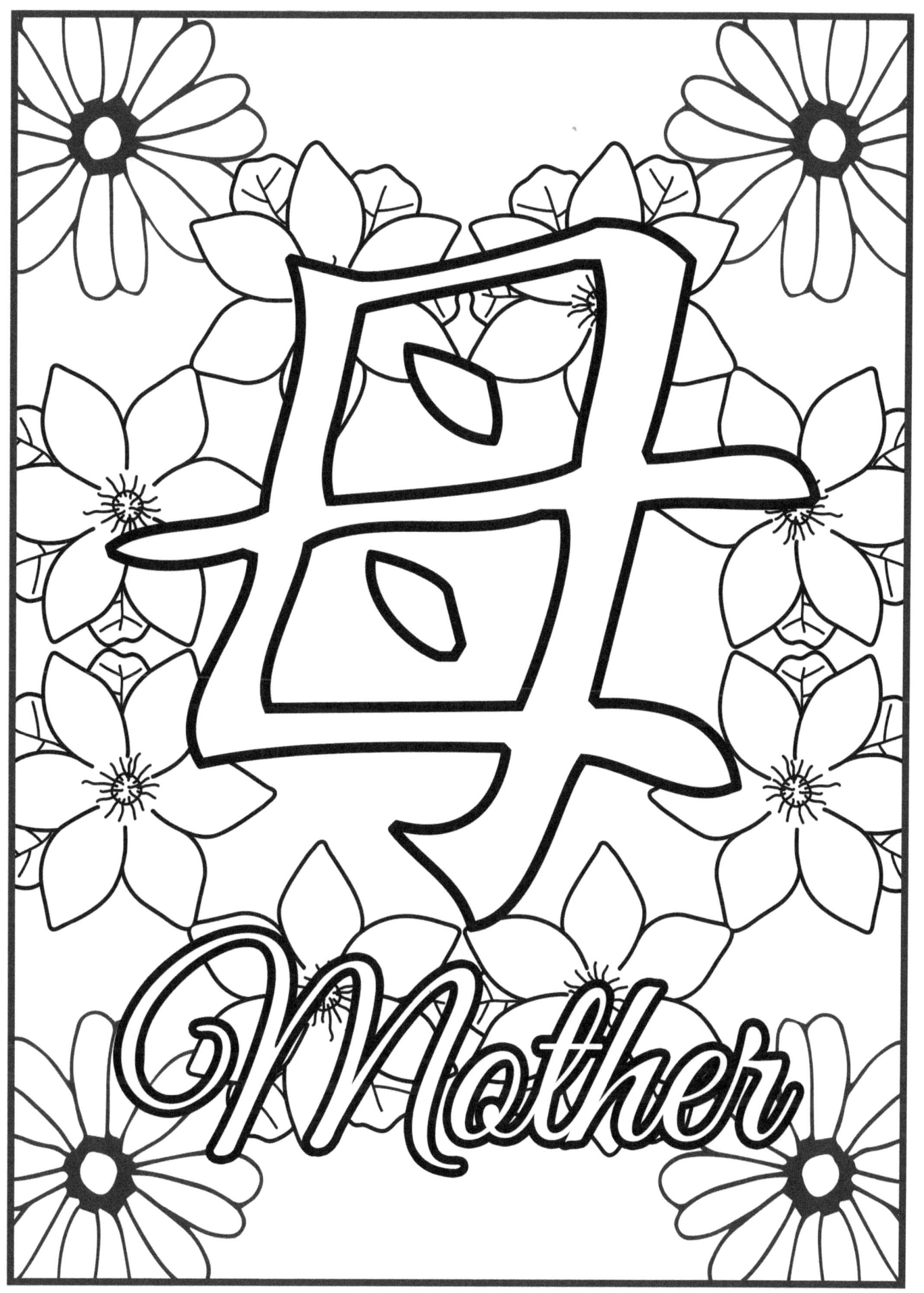

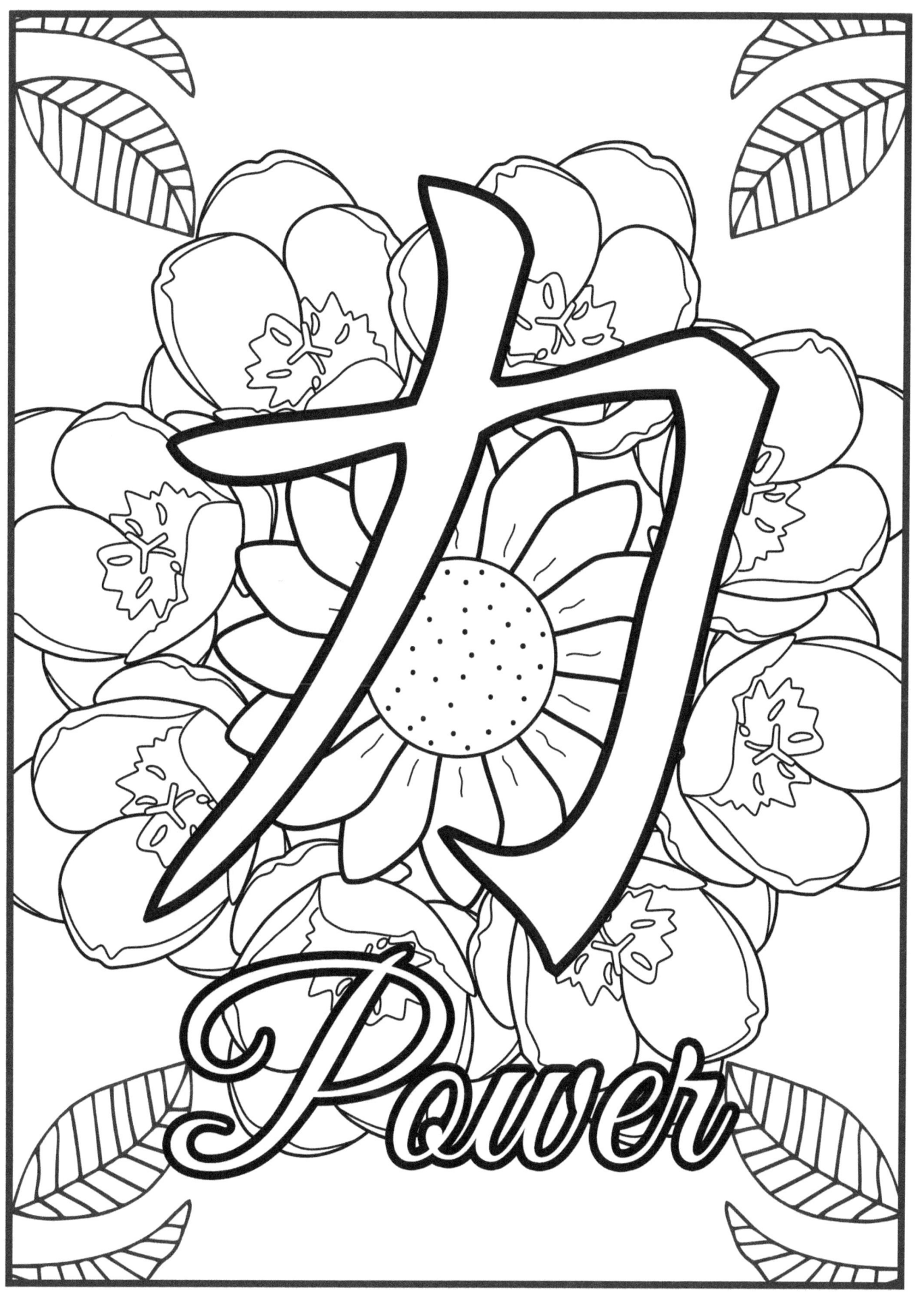

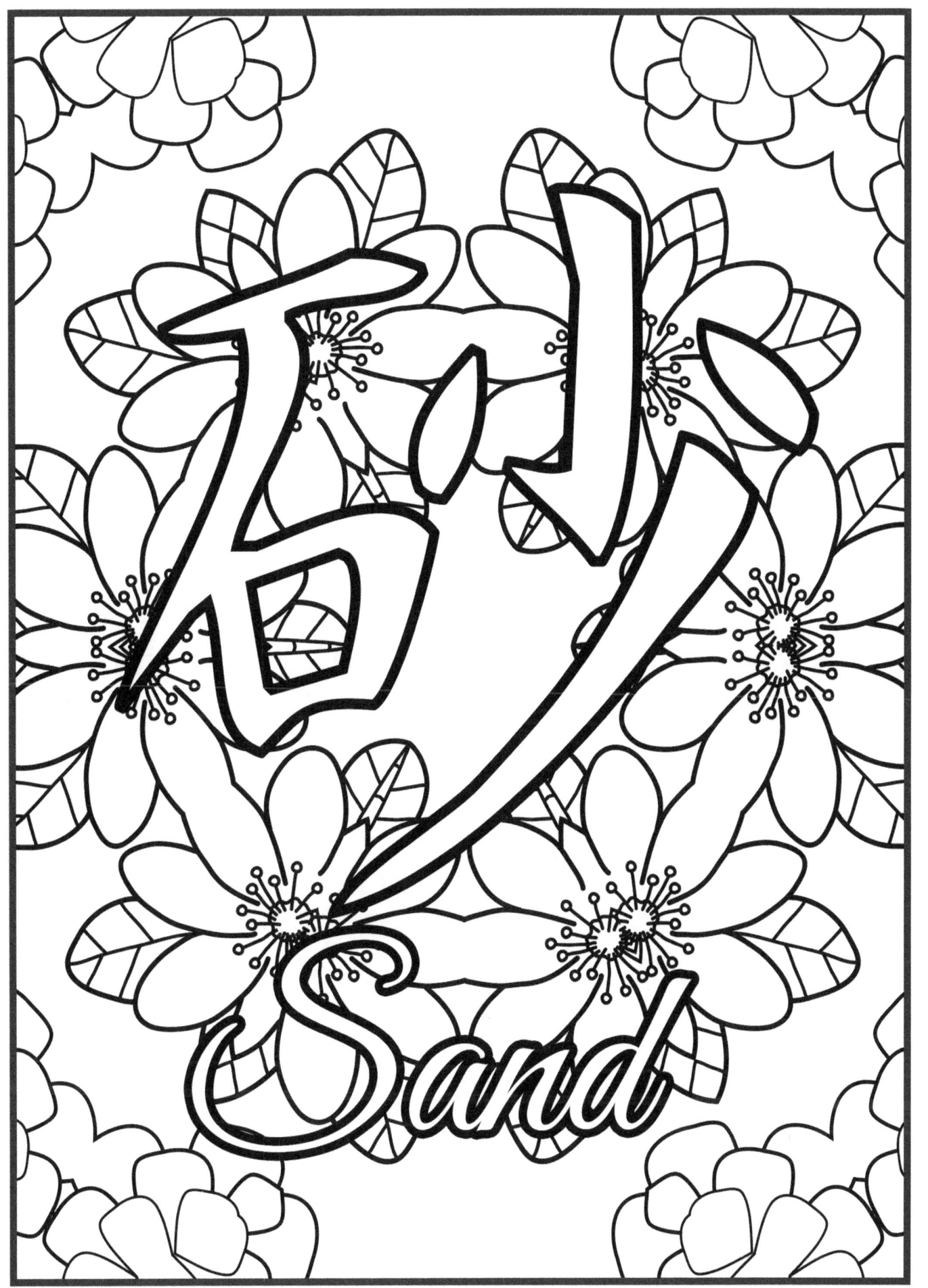

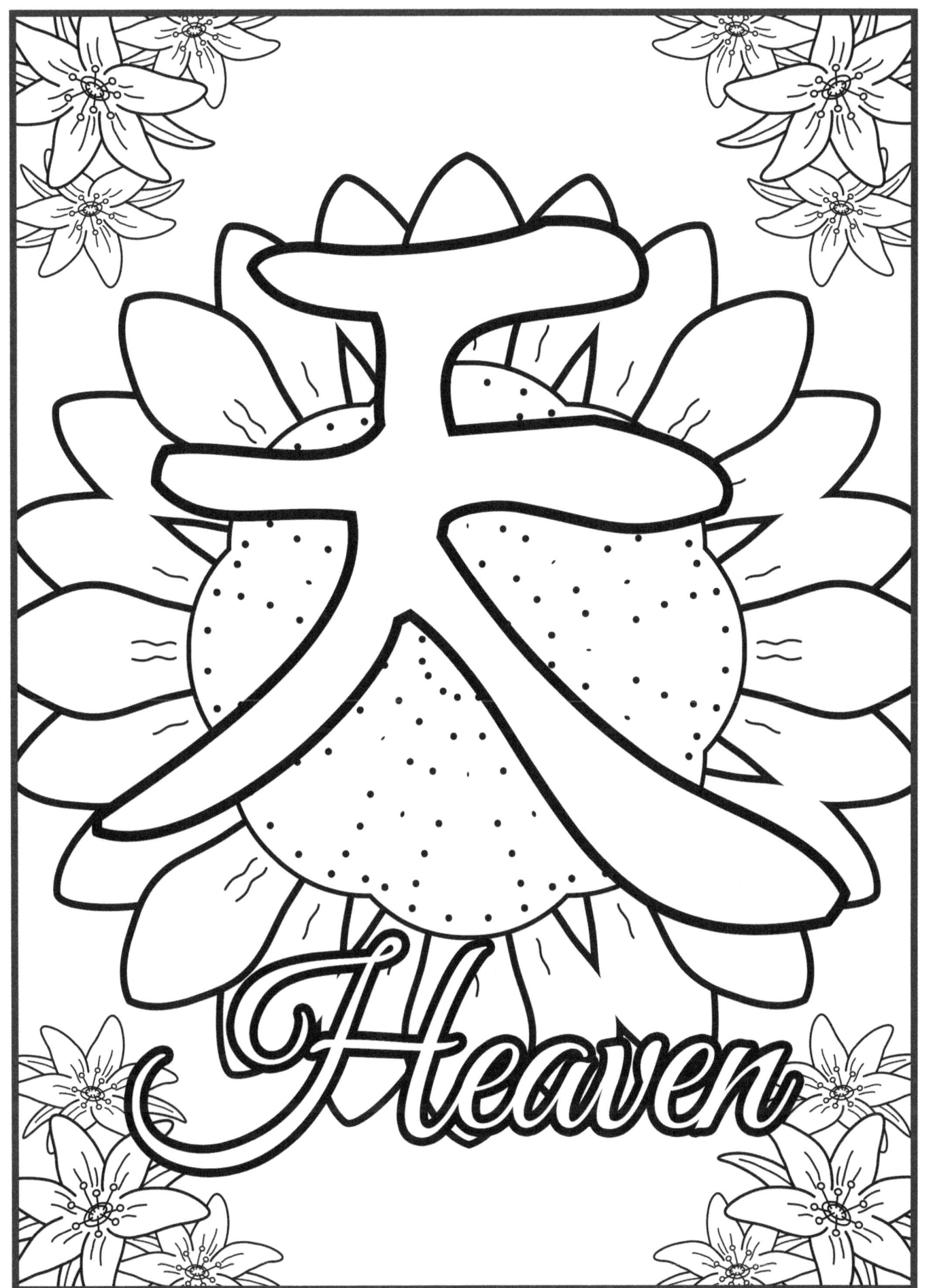

www.ingramcontent.com/pod-product-compliance
Lightning Source LLC
Chambersburg PA
CBHW080622190526
45169CB00009B/3264